Painting Country & City Landscapes *In Watercolor*

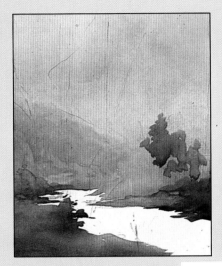
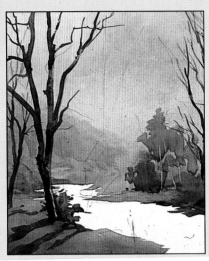
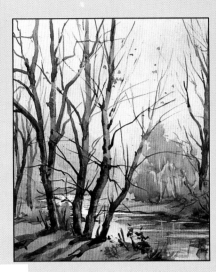

JOSE M. PARRAMON

Watson-Guptill Publications/New York

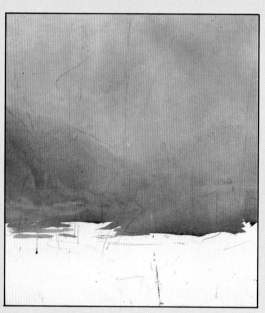

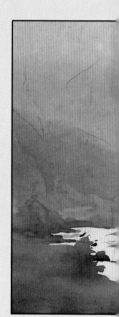

Painting
Country & City
Landscapes In Watercolor

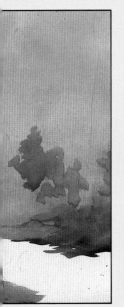
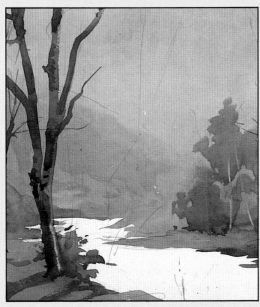
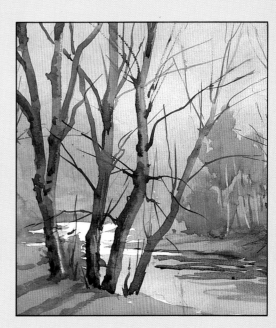

JOSE M. PARRAMON

Watson-Guptill Publications/New York

Copyright © 1988 by Parramón Ediciones, S.A.

First published in 1991 in the United States by Watson-Guptill
Publications, a division of BPI Communications, Inc.,
1515 Broadway, New York, New York 10036.

Library of Congress Cataloging-in-Publication Data

Parramón, José María.
 [Pintando paisajes a la acuarela. English]
 Painting country and city landscapes in watercolor / José M. Parramón.
 p. cm.—(Watson-Guptill painting library)
 Translation of: Pintando paisajes a la acuarela.
 ISBN: 0-8230-3605-7
 1. Landscape in art. 2. Watercolor painting—Technique. I. Title. II. Series.
 ND2240. P3813 1991
 751.42'2436—dc20 90-49244
 CIP

Distributed in the United Kingdom by Phaidon Press, Ltd.

Manufactured in Spain
Legal Deposit: B-35.178-90

1 2 3 4 5 6 7 8 9 / 95 94 93 92 91

The Watson-Guptill Painting Library is a collection of books that teaches the student of painting and drawing through an examination and detailed explanation of the work of several professional artists. Each volume demonstrates the techniques and procedures required in order to paint in watercolor, acrylic, pastel, colored pencil, oil, and so on—each with a specific theme: landscapes, still lifes, figure painting, portraits, seascapes, and so on. Each book in the series presents an explanatory introduction on that specific discipline followed by step-by-step lessons. In this book, *Painting Country and City Landscapes in Watercolor*, we will begin with a detailed look at the elements of landscape composition and at the materials available to the watercolorist.

But the most extraordinary aspect of this book is the comprehensive treatment of all the elements of painting—the choice of theme, the composition, color interpretation and harmonization, the effects of light and shadow, color value, color temperature, and so on. The professional artists featured here pass on their knowledge and experience along with their techniques, secrets, and tricks brushstroke by brushstroke, step by step. Dozens of photographs taken while the artists were painting add to the value of the lessons.

I personally directed this work with a team I am proud of, and I can say that I honestly believe this series of books really teaches you how to paint.

José M. Parramón
Watson-Guptill Painting Library

The artists

The artists appearing in this book have been selected on the basis of their educational contribution to the field of painting landscapes with watercolor.

Thus Gaspar Romero, who worked as a chemist before devoting himself to painting, shares with us his knowledge of the chemical composition of colors and the manufacturing process of watercolor paper. Prestigious watercolorist Guillem Fresquet chooses, frames, and composes. José M. Parramón, a painter with experience in various techniques, as well as an art teacher whose texts have been translated into several languages, shows us the wet-on-wet technique step by step. José Martínez Lozano, oil painter and watercolorist, demonstrates his capacity for creative synthesis by inventing and interpreting a landscape.

All of the artists make of learning to paint watercolor landscapes something exciting as well as informative.

The actual watercolor techniques will be demonstrated later, as the artists paint their paintings step by step. We devote this introductory chapter to the basic principles of composition and artistic interpretation.

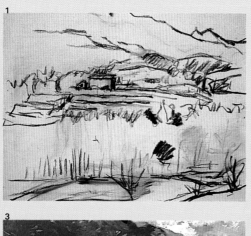

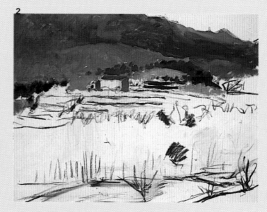

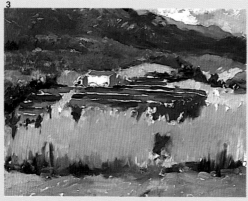

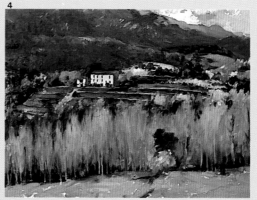

The outdoor theme

Selection of the subject

Eugene Delacroix, the French romanticist painter who paved the way for impressionism, wrote in his diary: "The theme is you yourself, your impressions, your emotions facing nature. You must look inside yourself, not around you."

This statement would come to reflect the ideology of the impressionists, on the basis of which landscape would acquire sufficient personality to become a theme in itself.

Up to that point, the inclusion of academic themes, the following of rigid norms of composition and proportion, and painting in the studio from memory had been the keynotes of landscape painting.

Rebelling against this formula, the impressionists put their easels out under the open sky and gave preference to the everyday scene over the invented literary theme.

Although all the impressionists painted themes that were considered trivial in their time, they nonetheless always saw a clear motif for a picture, were attracted by its particular form and color, and decided how to portray it according to their own laws before starting to paint.

Three factors guided the impressionists and the generations following them in selecting a subject: knowing how to see, knowing how to compose, and knowing how to render.

5

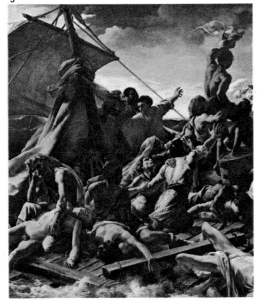

7

6

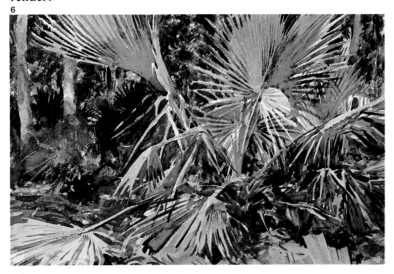

Figs. 1 to 4. (Previous page.) This landscape painted by José M. Parramón serves as a magnificent example of what this book seeks to achieve: to illustrate the various techniques of painting step by step through the words of the artist himself as well as through theoretical concepts of color composition—illustrated perfectly here by the warm colors used by Parramón in the foreground to create the illusion of a third dimension—which enables the reader to discover various practical solutions and "tricks of the trade."

Fig. 5. Until the arrival of impressionism, painting reflected the predominant moral, social, or political concerns of each age. The themes were limited to major historic, patriotic, or religious concerns. This painting by the French romanticist painter Theodore Géricault was suggested by a real historical occurrence: a shipwreck that mobilized public opinion and lead to a great public scandal.

Figs. 6 and 7. *Palmettos* by the American watercolorist John Singer Sargent at the Metropolitan Museum of Art (Fig. 6). *The Mountain Road* by André Derain at The Hermitage, Leningrad (Fig. 7); a painting belonging to the original fauvist movement, shows the full extent to which subject selection is open to the artist's creativity. In the case of Derain it comes down to juxtaposed colors separated only by the outlines of the shapes.

Plato's rule

The art of composition

It was the ancient Greek philosopher Plato who stated one of the few existing norms about the art of composition: *"Composition is finding and portraying variety within unity."*

Variety in form and color and distribution of the pictorial elements create diversity to stimulate and attract the viewer's attention.

However, a unity of composition pulls together this variety.

Since these concepts are complementary, we have to add the following to the Platonic norm in order to make it truly complete: *"Unity within variety, variety within unity."*

There are various factors determining this universal order.

1. Arrangement of forms within the space of the picture.
2. Symmetry and asymmetry.
3. Balance and compensation of masses.
4. The third dimension.

Arrangement of forms within the space of the picture

A basic aspect of composition is the logical distribution of forms within the space of the picture. Too much variety distracts the attention of the person contemplating the picture and fails to provoke any emotional response.

It's obvious that in order to achieve unity you have to "capture" the theme, the principal motif. The first complication arises when it's time to deal with such basic questions as: What elements of the landscape should be included in the picture and which can be safely omitted? How and where should the principal elements of the main motif be placed within the picture?

Thus the extraordinary American watercolorist John Singer Sargent developed a basic principle on synthesis, which he successfully followed all of his life: "In art everything that is not indispensable is detrimental." This takes on the authority of an essential rule.

8

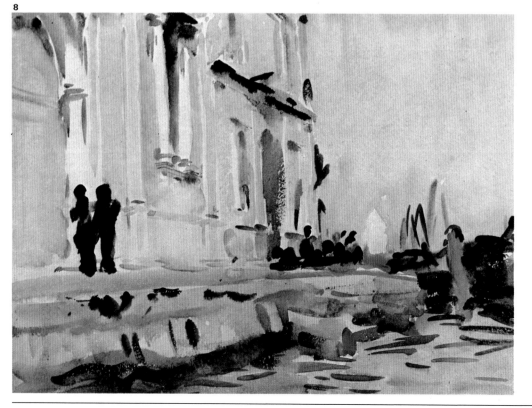

Fig. 8. The famous American portraitist John Singer Sargent—whose work evolved at the end of the nineteenth century and the beginning of the twentieth century—painted his portraits exclusively in watercolor, and he also painted watercolor landscapes. The painting by Sargent reproduced on this page shows this American watercolorist's extraordinary capacity to select and synthesize parts of the real motif in such a way as to arrange the shapes and spaces within the picture plane to attract the viewer's attention with "unity within variety."

The rule of the golden mean

The second factor of composition, symmetry and asymmetry, is found by applying the Rule of the Golden Mean.

In the first century B.C. a Roman architect named Vitruvius wrote the work *Of Architecture* dedicated to the Emperor Augustus. Vitruvius was in charge of decorating the murals of Pompeii and was an art theoretician like Plato. While working on the Pompeian frescoes, he had to deal with the question of how to best arrange forms within the space available and constantly asked himself which placement of the principal theme would be most effective.

Vitruvius found a solution through the rule that he dubbed the Golden Mean:

"For a space divided into unequal parts to be pleasant and aesthetically pleasing, the proportion between the smallest and largest section must be of the same ratio as that between the largest section and the entire picture."

Mathematically this law is expressed by the number 0.618. If you multiply the width of the picture by 0.618, you obtain the longitudinal division of the Golden Mean. If you repeat this same process with the height, and intersect these lines with the previous ones, you can determine where the composition's center of interest lies. These intersecting points can be either up, down, to the right, or to the left.

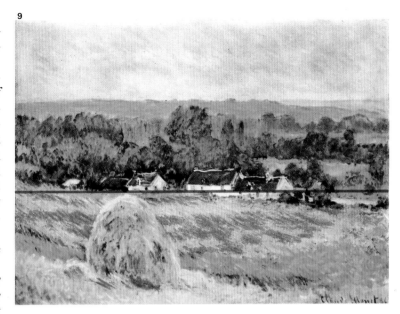

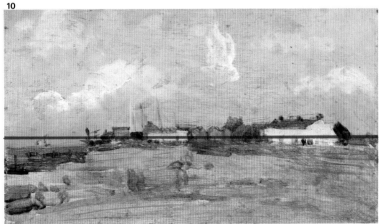

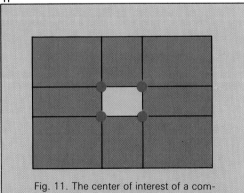

Fig. 11. The center of interest of a composition is not limited to only one place on the surface of the painting. If you multiply 0.618 by the width and the height, you obtain four "golden" points. A central theme placed at any one of these points will attract the viewer's attention.

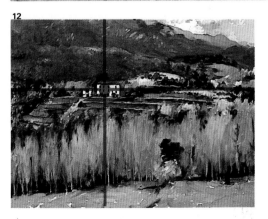

Figs. 9, 10, and 12. Three examples of the application of the Golden Section, the classical norm formulated by Vitruvius, which highlights the principal motif of a composition. The rule of the Golden Section was used as much by Claude Monet in his *Haystack*, The Hermitage, Leningrad (Fig. 9), as by James McNeill Whistler in his *White House*, Freer Gallery of Art, Smithsonian Institute, Washington (Fig. 10), and by José M. Parramón in his landscape (Fig. 12). Whether or not they realized that they were using the Golden Section is not in itself important: The fact that three different artists selected the same location as being best for the placement of their main motif is validation enough of the principle behind the Golden Section.

Asymmetry and balance

Symmetry and Asymmetry

Just as symmetry is synonymous with unity so asymmetry is synonymous with variety.

When composing still lifes, figures, or portraits, the artist can modify the symmetry or asymmetry by simply changing the model's position. This obviously is not the case with landscapes. Even then the artist can, however, change the angle of his or her point of view to find the most satisfactory angle.

A symmetrical composition is usually not the norm in landscape painting. The majority of artists opt for an asymmetrical distribution which, when combined with a three-quarter placement of forms to create the illusion of perspective, imparts life to the motif—unity within variety.

Balance and compensation of masses

The Roman scale presents us with a clear example of the balance and compensation of masses. Two weights of differing sizes are placed at two different lengths away from the central fulcrum; equilibrium is achieved thanks to an inverse ratio between the weight of the masses and their distances from the fulcrum.

In the asymmetrical arrangement of a landscape the fulcrum corresponds to the ideal axis of the composition, and the "weights" to the predominating masses or shapes whose size, distance, and tonal values must be compensated for if the composition is to be well balanced.

Figs. 13 and 14. In landscape painting it is not advisable to use a symmetrical arrangement of forms. The great landscape painters have preferred an asymmetrical composition (Fig. 14) that, when combined with a nonfrontal three-quarter placement of forms, lends itself to a visual style favoring "unity within variety."

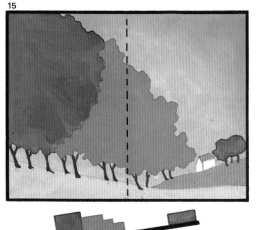

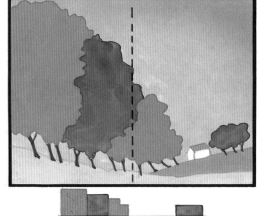

Figs. 15 and 16. The aesthetic balancing of masses is achieved not only by the distribution of volumes but also by a balance of tonal values. In Fig. 15 the dark mass of the left-hand tree is not offset by the less intense masses of the central trees and the little house to the right of the picture. The pictured scales show that a solution to the problem would be to move the dark mass closer toward the center (Fig. 16).

The cylinder, the cube, and the sphere

The third dimension

The effect evoked by the third dimension is a decisive factor in landscape painting. The question is how to overcome the limitations of the two-dimensional picture space by reproducing within it the third dimension offered by the subject—depth. The viewer should be able to enter the picture, to walk down the paths, and wander between the trees of the forest, both near and far.

When discussing the topic of depth—as well as other points of teaching art—it is necessary to mention Paul Cézanne, to whose extraordinary genius modern painting is indebted. In Cézanne's work everything, even evanescent substances such as water, clouds, and air, have a third dimension.

Aside from his use of pure colors and contrasts between warm and cool colors, the master achieved a sense of volume by simplifying all forms to a cylinder, a cube, or a sphere.

In fact, all natural forms can be reduced to these geometrical forms. Consequently it follows that a person who can draw these three shapes perfectly can depict volume within the flat surface of a picture.

There are, however, other factors that contribute to creating the effect of depth, namely:

1. Inclusion of foreground.
2. Superimposition of successive planes.
3. Perspective.
4. Contrast and atmosphere.
5. "Close" and "distant" colors.

Fig. 17. Landscapes with all of their natural forms and shapes have intrinsically geometric structures. The genius of Paul Cézanne was to apply this geometric ''spirit'' to all of his works. By taking the premise that all natural forms can be reduced to a cube, sphere, or cylinder as a point of departure, he succeeded in giving volume to the objects in his pictures and transmitting the sensation of a third dimension. So, practice drawing these three geometrical forms before you begin painting, and make an effort to discover which form or forms appear in your landscape.

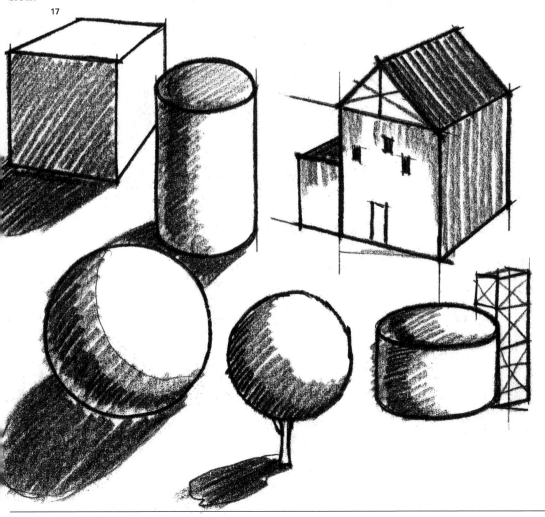

17

The world in three dimensions

Inclusion of foreground

If one of the main elements of a composition is located in the foreground, viewers will immediately experience the sensation of depth. The existence of the foreground as a point of reference automatically situates the rest of the picture in a third dimension. Upon seeing a foreground, the human eye instantaneously interprets distance between what is close up and what is farther away.

Superimposition of successive planes

If there are bushes or rocks close by, a small cluster of village houses behind them, and, even further, on a third plane a village church or a mountain, then we are looking at a superimposition of successive planes that represent and accentuate the third dimension. Screen backdrops used in theaters employ a similar superimposition of flat planes to produce the illusion of depth.

Nature herself provides the painter with innumerable sources of inspiration for portraying depth when painting a landscape. It is up to the artist to frame the picture in order to select landscape elements that accentuate overlapping planes rather than one uniform plane—if it is his or her intention to do so, of course.

Perspective

In order to paint good landscapes it is vital to know the laws of perspective.

All subjects can be rendered with perspective. Streets, roads, rows of trees are all there for the painter to take advantage of in transposing the third dimension to his or her picture. To achieve this, it's fundamental that the painter select a vantage point that accentuates and dramatizes the effect of depth.

Fig. 18. The foreground of this painting not only dramatizes and brings closer the center of interest of the composition, but it also makes the white house look further away and creates the visual effect of a third dimension.

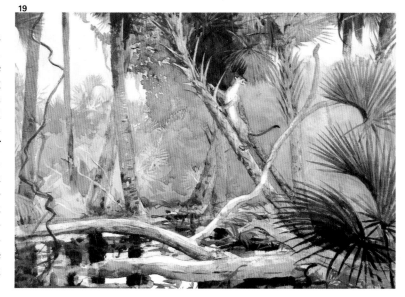

Contrast and atmosphere

In his *System of the Arts* the German philosopher Hegel provides us with a magnificent discussion of the sensation of depth through the intensification of contrasts.

According to his theory, the further away an object is, the more it loses its color and the more indeterminate its form becomes, because the contrast between light and dark becomes progressively blurred.

The crux of Hegel's important discoveries can be summarized by the following two general rules:

The further away something is, the more it tends to discolor and lean toward blue, violet, or gray.

The foreground is always more distinct and full of more contrast than the background.

The artist can and indeed *should* take advantage of his or her creativity to introduce values that do not exist in the original landscape. The possibility of creating contrasts not seen in the landscape puts an invaluable means of enhancing the illusion of air and space between the various points of the landscape—that is, the third dimension—in the hands of the artist.

"Close" and "distant" colors

This, as well as many of the other factors discussed up to now, is based on nothing more than sensory impressions. However, as Hegel demonstrated and as hundreds of painters since him have reaffirmed, cool colors "distance" the motif whereas warm colors "bring it closer" into the foreground.

For intance, in the order of closeness from closest to least close are the colors yellow, orange, red, and carmine. The distribution of the most to the least distant colors are green, blue, and light bluish gray.

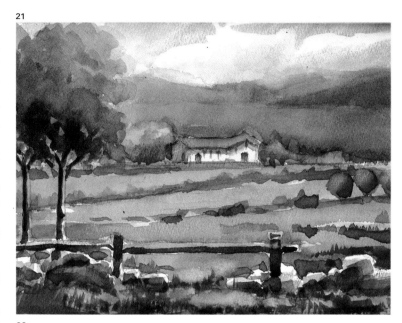

21

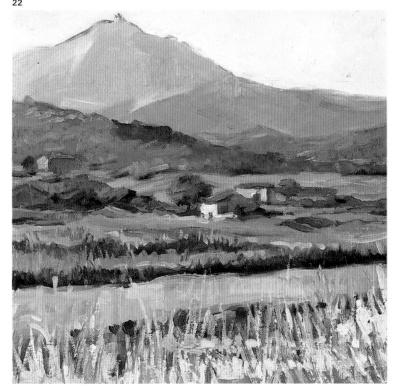

22

Figs. 19 and 20. Winslow Homer's work *In the Jungle* (The Brooklyn Museum) is a fine example of the use of superimposition of planes to create a sensation of depth. *Road in the Forest of Bolonia* by Matisse (Pushkin Museum, Moscow), invites the viewer to walk along the path. This painting exemplifies the use of perspective as the sole device in creating an illusion of depth; the flat areas of pure color that Matisse used did not help to achieve this effect in any other way.

Fig. 21. Another way of creating the third dimension in a flat picture plane is through the "air," or the atmosphere, found between the diverse elements of the landscape.

Fig. 22. Color, which heightened the depth of the previous painting, achieves the same effect in this illustration through the use of warm and cool colors. This work, with its yellow foreground and grayish blue background is a perfect example of how warm colors bring objects closer and cool colors make them recede.

Depict, invent, create

Rendering the landscape

Now we will examine some of the guidelines for correct artistic rendering.

Capacity to depict

The painter's mental library plays a major role in this process. While an artist makes an initial appraisal of a subject, perhaps the colors of van Gogh, the forms of Cézanne, or the memory of a particular film will pass through his or her mind. The ability to retrieve images will lead the artist to imagine, modify, and change what he or she observes in the original model.

Capacity to combine the real with the imaginary

The ability to see colors and forms distinct from those of the actual landscape enables the artist to imagine his or her *own* landscape. By painting what memory dictates and at the same time retaining reality as a pictorial reference point, the artist achieves a symbiosis between the imagined and the real.

Capacity to create

Creativity is basically the outcome of a *new attitude toward something we want to change*. It is fundamental then, that the painter's state of mind be directed toward solutions different from those supplied by nature. An artist should transfer his or her pictorial knowledge and personal experience to the painting in an attempt to create a different work. An artist should also record the sensory impressions that he or she truly experiences, his or her own individual mode of contemplating a motif.

One danger: the subject that swallows a painter

The postimpressionist painter Pierre Bonnard, an authority on modern painting, documented this danger—a danger that all painters encounter—by saying:

"The point of departure of a picture is basically an *idea*. This initial idea, however, tends to disappear in face of the real physical subject, which unfortunately invades and then dominates the painter. When this happens the artist never ends up painting *his* picture."

Cézanne's experience may aid many painters who need to distance themselves from a subject's overbearing influence.

Before putting himself to work, the great master gathered up all of his willpower and stubbornness, both of which were considerable. "I have a very definite idea of what I want to do with a theme, and I accept from nature only that which fits in with my idea." And he painted in brief sessions, repeatedly redoing what didn't please him, firmly clinging to his initial conception of the theme.

Some final words of advice

Above all, cultivate yourself artistically. Do this not just by reading books on the history of art and different eras and their styles, but by analyzing the actual paintings of current artists, periodically visiting exhibitions, and mantaining a permanent predisposition toward study and experimentation. To facilitate the preparation of studies, always carry with you a block of paper on which to jot down notes that could come in handy for a future landscape.

It's very important to have an extensive library of books on the history and techniques of painting and to read and consult them frequently. Inspiration is not an unattainable entity that wanders around ethereal regions choosing which artist to bless. As the great artists of all times have testified, inspiration is built on hard work, investigation, and continual experimentation.

Try not to ignore the camera either. Some painters are opposed to its use, but many others take full advantage of it to try out various frames or settings of a subject, to alter the lighting, or to select which landscape out of many to use as a theme. You can also photograph the landscape that you

have just finished painting and study it later in the peace and quiet of your own home. There you can compare your interpretation with the real subject and, if necessary, rectify, finish, or redo the painting.

The work of selecting, composing, and interpreting is nicely summed up by the reply that Picasso gave to Genevieve Laporte when she asked him how to paint. "You want to be a painter? Observe. Never stop observing your surroundings."

23

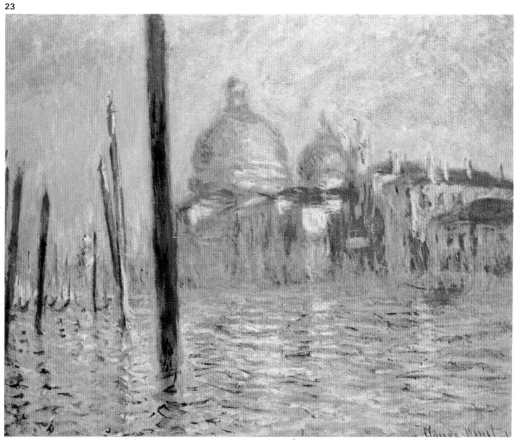

24

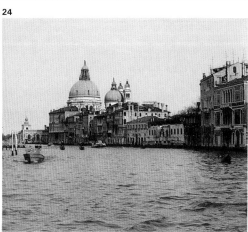

Figs. 23 and 24. Monet's picture *The Grand Canal* (Boston Museum) is a fine example of artistic interpretation of a motif. Such an interpretation is the result of three basic components: artistic interpretation of reality, combination of reality with imagination, and creative capacity. In regards to the first component—reality— Monet expressed it through the language of the impressionists for whom light and color were essential. Many other kinds of interpretations are possible, but this alternative was the one that fits the particular aesthetic concepts of the impressionists. Thus we see that the artist must interpret both the color and form of the subject. The second component refers to the artist's capacity to envision other landscapes while using a real subject as a basis. This photograph of the Grand Canal in Venice, taken from an angle similiar to that of Monet's picture, shows us that the great impressionist painter added desired elements to the composition: He painted the posts of gondola piers, sticking out of the water in the foreground, to create a greater sensation of depth. This same photograph shows the extraordinary creative capacity Monet displayed in incorporating a totally distinct spectrum of color, and painting the canal water and the middle ground with very warm-colored brushstrokes to create volume. Creativity is the third factor; the artist's attitude of mind must be directed toward painting a personal, unique, and individual picture that reflects all of the sensory reactions he or she experienced while contemplating the motif.

José Gaspar Romero, watercolorist and chemist

The Spanish saying "he used to be a cook before becoming a priest" means that someone has learned through experience. This saying applies perfectly to José Gaspar Romero, president of the oldest and most important watercolorists' association in Spain: He was a chemist before becoming a painter.

Now he dedicates all his time to art much the same way as Paul Gauguin did when he lived in Tahiti and abandoned his restriction to weekend painting.

Gaspar Romero's previous occupation is, however, still relevant to his current one: few of today's painters know as much about the chemical composition of the colors they use as he does. Or, for that matter, paper—the usual ground for watercolor—since Gaspar Romero also spent time manufacturing paper. From all of the above, it is clear we are in front of an artist who is capable of giving us a very thorough orientation to watercolor materials in particular.

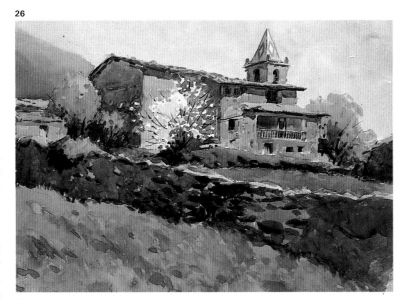

26

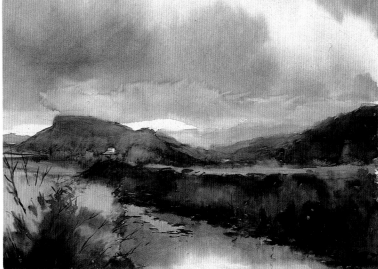

27

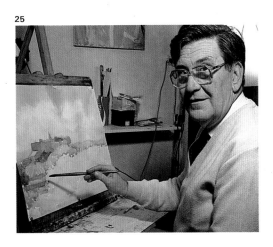

25

Fig. 25. Gaspar Romero is a watercolor artist with many years of experience. He has won various prizes and is president of the Catalan Watercolorists' Association, the first such association founded in Spain in 1864.

Figs. 26 and 27. Two magnificent landscapes by Gaspar Romero. An expert chemist and watercolorist, he will explain the composition and characteristics of watercolor and other watercolor materials. At the same time he will give us a step-by-step demonstration of his painting techniques.

28

Fig. 28. Gaspar Romero, like the majority of professional artists, has a carefully selected library of art books in his studio, not to mention the stereo set that makes his work at the studio more pleasant.

Gaspar Romero's colors

The colors

"I prefer wet or creamy watercolors. I never use liquid watercolors or airbrush," he says. Nor does he use the cheaper pans of dry watercolors of nonprofessional or "student" quality. He opts for creamy watercolors "because they dilute more easily, much faster." As for wet watercolors, Gaspar Romero uses both Winsor & Newton and Schmincke because they "have a lot of density." That is, either will provide you with a large quantity of color.

"Generally speaking I work with three palettes—those of Grumbacher, Schmincke, and Winsor & Newton—because of the mixtures, the varying shades or hues of colors involved. Schmincke's cobalt blue, for example, is not the same as Winsor & Newton's cobalt blue."

Gaspar Romero doesn't limit himself to a commercially produced color range, to the colors that come in a box. He buys a special palette box within which he places the colors most to his liking so that they are easily available for mixing when it's time to paint (Fig. 29). What is his usual spectrum of color? You see it here before you.

29

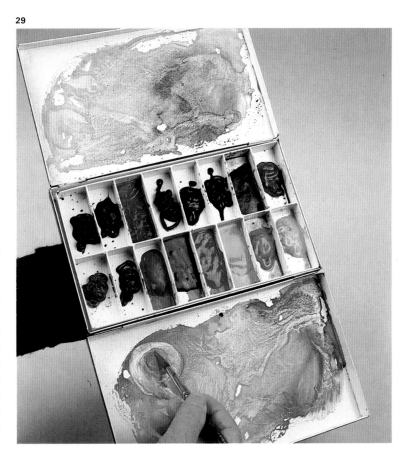

Fig. 29. Gaspar Romero uses pan watercolors and creamy tube watercolors indiscriminately. In order to paint the picture that we are soon going to see, he uses the creamy tube colors and works with this special palette box. The artist fills the box's sixteen compartments with creamy watercolors which he then combines and dilutes on the metal lids that serve as palettes.

Fig. 30. This is the range of colors used by Gaspar Romero to paint his watercolors.

30

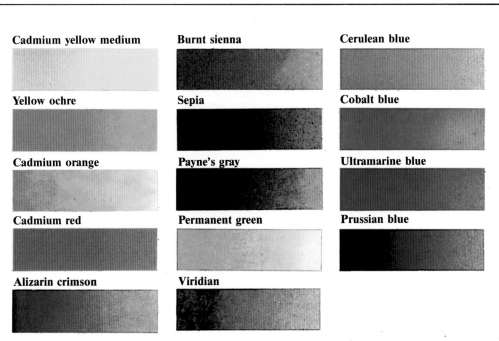

Cadmium yellow medium	Burnt sienna	Cerulean blue
Yellow ochre	Sepia	Cobalt blue
Cadmium orange	Payne's gray	Ultramarine blue
Cadmium red	Permanent green	Prussian blue
Alizarin crimson	Viridian	

The characteristics of watercolor

We asked this painter-cum-chemist to tell us more about watercolors.

"First let's talk about the permanence and opacity, or the coating, capacity of watercolors. Cadmium colors offer two advantages in this respect: They resist light well and are very opaque. If transparency is called for, you have to mesure the quantity of paint that you load the brush with very carefully when using cadmium. On the other hand the blues tend to be transparent except in special cases, such as with blue-gray, some Japanese color ranges, or with an adulterated cobalt blue that has had extra ingredients added to it to make it opaque. Prussian blue has the special chemical quirk of fading in the light of day, but recuperating its hue in darkness; this is the result of a photochemical property of the color. This instability has always been a problem when utilizing Prussian blue, along with its frequent dominant tendency toward green. Recently, however, new organic derivatives of thallium kyanite have begun to offer a very wide range of stable blues and greens that allow you to work with security.

"No one ever purposely leaves watercolors outside in the sun, but you should keep in mind that there's a definite conservation problem if that should happen. Those of us who paint with watercolors are called watercolorists. That is, we are identified by our medium. This entails a great responsibility; our detractors always attack our medium as being too fleeting and impermanent in nature. Our reply should be to use the best possible materials available in creating our work. We can point out that paper resists the passing of years much better than canvas."

Gaspar Romero says that he owns watercolors painted in the 1940s that still maintain their color and freshness forty years later. The watercolors of Mariano Fortuny are also still bright even though they were painted in the nineteenth century (Fig. 32).

"Of course, back then, watercolors weren't mass-marketed and sold commercially, and the painters themselves often made their own colors. The oldest of the firms,

Fig. 31. Gaspar Romero explains that the cadmium colors like this upper yellow are fast and opaque. The blues, quite on the contrary, tend to be transparent.

Winsor & Newton, started manufacturing watercolors in 1840. The English painters were initially very wary of these colors in pans or tubes being sold in stores. This motivated Winsor & Newton to publish a voucher claiming that their watercolors were guaranteed to be of the same quality as those made by the painters themselves."

It would be appropriate to close this section on chemistry with a brief mention of what watercolors are composed of.

"It's very simple," Gaspar Romero explains: "color pigments (mineral, organic, or synthetic) just like any other paint, a good proportion of distilled water, sufficient gum arabic or senegalese, a discrete quantity of glycerine, and a small touch of oxgall and phenol."

"Logically enough, each substance serves a function: The gum arabic makes the color stick to the paper; the glycerine retards drying; the oxgall allows us to extend the color smoothly without having it run or break off; and phenol helps preserve the watercolor."

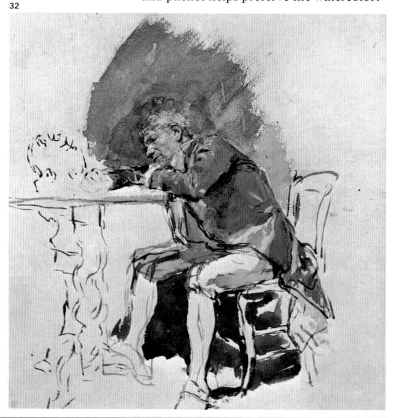

Brushes

Brushes are not chemical products, but Gaspar Romero also has some very definite ideas about them. For one, he doesn't use sable-hair brushes, often regarded to be the "king of brushes" by many watercolorists. What does the president of the Catalan Watercolorists Association have against sable? "It's very expensive if you take into consideration how fast it deteriorates. Other brushes wear out too, but turn out to be more economical in the long run."

Winsor & Newton makes a brush that is a mixture of mongoose or squirrel hair with synthetic hair. This is the brush that Gaspar Romero likes: It doesn't deteriorate with use (thanks to the synthetic hair) but can carry a larger load of water than a totally synthetic brush (thanks to the mongoose hair). This mixed brush, besides lasting longer, is not

33

as expensive as a sable-hair brush. It is sold under the brand name Sceptre (Fig. 33).

How many and what number brushes should you own? A number 14, a 12, a 6, a thin number 3 or 4 brush, and a broad flat brush of either hog's bristle or stag hair, which is nowadays often referred to as a Japanese brush—its broad end is 2 inches (5 cm) in width. Last of all, a special brush with a transparent plastic handle. The tip of this handle is beveled so you can use it to "open up" white spaces in a damp watercolor painting (Figs. 34 to 37).

34

Fig. 32. Mariano Fortuny was one of the most important European artists of the nineteenth century. In this half-finished watercolor, Fortuny demonstrated his mastery of watercolor techniques and the rendering of the human figure.

Fig. 33. According to Gaspar Romero, the special brush made half from monsoon or squirrel hair and half from synthetic hair by Winsor & Newton is a cheaper, perfectly acceptable alternative to the sable-hair brush.

Fig. 34. From left to right, three round sables brushes and a round number 24 ox-hair brush.

Fig. 35. Here we have a flat brush; it is a Japanese stag-hair brush recommended by Gaspar Romero, who uses it for wetting surfaces and painting large areas of ground or sky.

Figs. 36 and 37. This is the tip of a kind of blunt-edged, beveled tortoise-shell brush that professional watercolorists use to scratch open white lines on wet surfaces (Fig. 37).

35

37

36

Paper, water, palette

Gaspar Romero uses three different kinds of watercolor paper indiscriminately: thick grain, medium grain, and fine grain. He doesn't prefer any particular brand, but he works only with high-quality paper. As far as measurements are concerned, the paper size he uses most frequently is 18 inches × 24 inches (46 cm × 62 cm); he never goes over 22 inches × 28 inches (50 cm × 70 cm).

We might mention that Fabriano makes a 18 inches × 24 inches (46 cm × 62 cm) pad of watercolor paper and that this size of paper is easy to find in almost any brand.

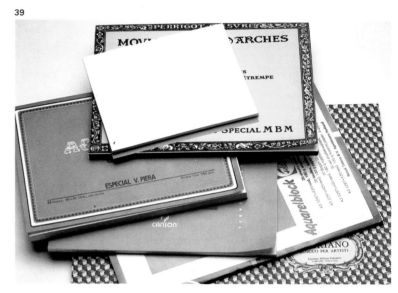

As far as weight or thickness of paper goes, 140 lb. (300 grams) is the minimum.

It only seems logical to talk about water, too, when dealing with watercolors. Gaspar Romero always works with running tap water. "But not with two water containers. I prefer only one," he says. In effect. many watercolorists use two containers: one for dirty water (in which they get rid of surplus leftover color), and one for clean water (in which they wet their brushes before loading them with a new color). Why does Gaspar Romero prefer a single water container? "When the water is a little dirty, all the colors harmonize better than when it's clean," he declares.

High-calcium content water used to be able to cause colors to precipitate. Nowadays this danger has been eliminated thanks to the new bonding agents that have been added to colors. Neither is it necessary to add moistening agents to the water anymore, since manufactured colors already contain them.

Then there's no problem with the water? Yes, one that Gaspar Romero points out: chlorine. "Water with an excessive amount

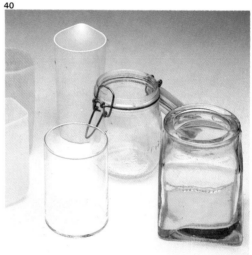

of chlorine can cause discoloration." Chlorine is here to remind us that perfection is impossible in this world.

Outdoors as well as in the studio, this artist always paints with his paper support in an almost vertical position with a very slight incline. Really quite as though he were painting in oil.

There are many ways of going about painting a picture in the studio: using photographs as a guide, referring back to previously made pencil or pen sketches.... Maurice Utrillo painted almost all of his famous Parisian landscapes from postcards that he bought at the corner store.

Fig. 38. Quality watercolor paper carries a watermark—an impressed design with the name of the manufacturer on it, which is visible when held up against light.

Fig. 39. Watercolor paper comes in individual sheets or in blocks that are bound on all four sides to prevent any warping or buckling from wetness.

Fig. 40. The first thing you need for watercolor painting is water. We recommend using glass containers with a minimum capacity of half a quart, similar to the ones in the picture, as well as an unbreakable plastic container for painting outdoors.

Previous draft and the first phase

In this particular case Gaspar Romero uses an outdoor watercolor sketch as a guide; it offers a very rough rudimentary resolution of the principal artistic problems that he encountered. This sketch is in front of him during the entire painting process.

All the useful suggestions of the sketch will be incorporated. The unsuccessful ones will be coldheartedly discarded. All the rest will be up to the inspiration of the moment. As Whistler in his day commented to a judge, "Two hours to paint the picture and the rest of my life as an artist to enable me to paint it in those two hours."

Sketching with paint

Gaspar Romero starts painting in the way prescribed by Titian: no pencil, just a brush loaded with a very diluted ochre-yellow that he uses to sketch directly onto the paper. He outlines the main shapes, the group of buildings is shaded in—in ochre for the time being—to indicate its relative importance as the pictorial center of interest.

Fig. 41. This is the water-color sketch that Gaspar Romero uses to paint a landscape in his studio.

41

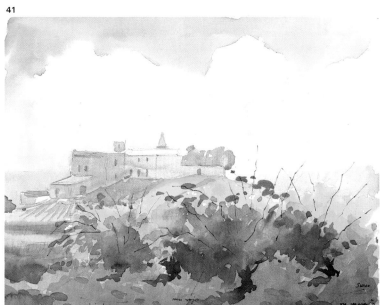

42

Fig. 42. To start a water-color painting you can either draw with a drawing pencil or directly begin to paint with a number 3 or 4 brush. Gaspar Romero has put the latter system in practice by drawing in an ochre-yellow shade corresponding to the dominant color tendency. "Lead pencil dirties the picture and is sometimes visible in the finished picture," he explains. "This ochre-yellow color will become invisible; it will be absorbed by the rest of the picture."

The second phase

The basic tones

Once the sketch is finished Gaspar Romero paints in the sky. The painter begins by holding the support at a horizontal position so that he can wet the paper with a very wide flat brush full of clean water. He only wets the area that corresponds to the sky.

Once the general wash of blue has been applied, the artist starts to reserve blank spaces for the clouds. Using a slightly darker blue, he starts to draw and paint—painting by drawing and drawing by painting—the distant mountains behind the house/castle.

This entire section is painted while damp so that the horizon blends with the color of the sky and the background mountains to create a feeling of depth, a third dimension. It also has an atmosphere similar to that of Velázquez's *Meninas*... that is, if we take into consideration the difference between oil painting and watercolor, and Velázquez and Gaspar Romero.

Now Gaspar Romero places the board at a medium slant. He paints with cadmium yellow, cadmium orange, and a considerable amount of water, leaving the space corresponding to the vines very light in color. He uses light oxide red to cover the area that is going to be the foreground earth.

At this point all the tones of the watercolor are very pale, yet they nonetheless mirror the basic spectrum of the landscape colors: a blue sky with white areas reserved for the clouds, a violetish colored horizon with mountain outlines, pale earth tones, a touch of greenish gray depicting the castle, and, in the foreground, a series of diffuse warm tones and colors for the vines and earth. Last of all, a small area of pale, but bright, green in the center of the lower left-hand side.

43

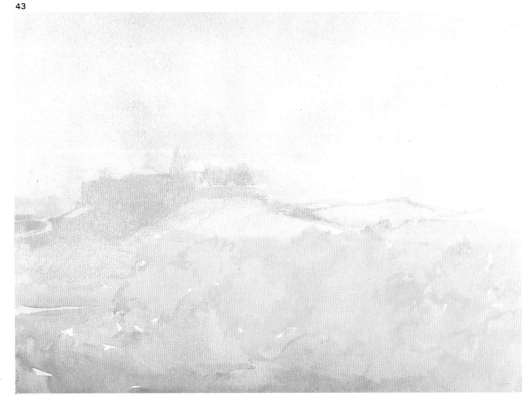

Fig. 43. The basic tones applied in the second phase establish what the final hues and color tendencies of each area will be. The sky and the background forms have been resolved by wet watercolor or by what is known as the wet-on-wet technique, in an attempt to create distance and space.

The third phase

The resolution of some forms

Gaspar Romero begins the third phase with the sky, too. Once again he wets this area with water and paints on *his* version of "sky blue," using a number 14 brush (Fig. 44). The extra water running off the brush is absorbed by a paper towel. (Run-of-the-mill kitchen paper towels will do just fine.) He works quickly.

Now using cobalt blue with just a touch of carmine, he gives a violet tone to the background mountains. As he continues painting in the mountains with this color mixture, Gaspar Romero makes sure to leave some blank spaces, or "holes," for the vine leaves.

Next he concentrates on the cluster of houses. He continues to use cobalt blue, but now also adds a ground of burnt sienna. In keeping with the speed characteristic of watercolor, he makes quick, decisive strokes. He adds a little green that mixes in with the cobalt blue to form what will be the small tree behind the castle.

During this stage the center of the lower left-hand side—well, just a small corner of this area, to be more exact—begins to suggest the forms and colors that the final version will take. Gaspar Romero focuses his attention on the group of buildings and begins to shade them in. He attacks the vines with yellow ochre and cadmium yellow, absorbing any extra color with paper.

Figs. 44 and 45. Observe the necessity to alternate brushes, depending on the size of the area being colored. A fat number 14 brush is used for a broad area such as the sky, and a thin number 3 brush is used to take care of small details such as the windows and doors of the buildings in the background.

44

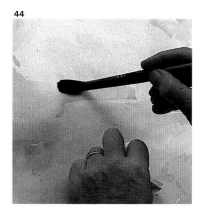

45

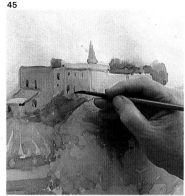

46

Fig. 46. Gaspar Romero initiated the third phase by painting the sky, which he then considers finished for the time being. Various colors besides cobalt blue were used to capture the sky; very small, mixed, and diluted amounts of madder, cadmium red, and burnt sienna were used to paint the dark areas of the clouds and the limits of the horizon.

The fourth phase

Adding depth to the central area

Gaspar Romero applies a bright green—a mix of emerald green and cadmium yellow—to the fields below the buildings.

By adding some cobalt blue to this mixture of green and yellow, he obtains the right green for the trees behind the castle.

With a very diluted mixture of burnt sienna and a little bit of cadmium yellow, he paints in the tiles of the building. Every once in a while he mutes a recently applied color with his finger and soaks up any excess water from the brush.

Only the vines are left to do. Gaspar Romero makes rapid splotches of medium cadmium yellow, cadmium orange, and yellow ochre.

Once the general tone range has been established, it's only a question of filling in the forms with colors in keeping with it. The painter keeps tones clear by leaving open spaces, and the way he creates depth with lighter and darker tonalities.

Fig. 47. Romero is constructing forms and intensifying colors. He has created depth in the foreground by diversifying its color with various tones of yellows, ochres, and oranges.

47

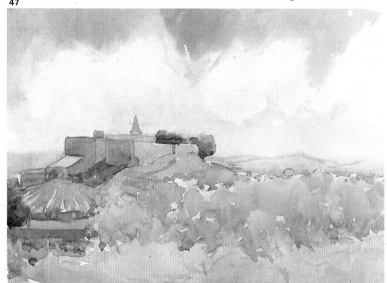

48

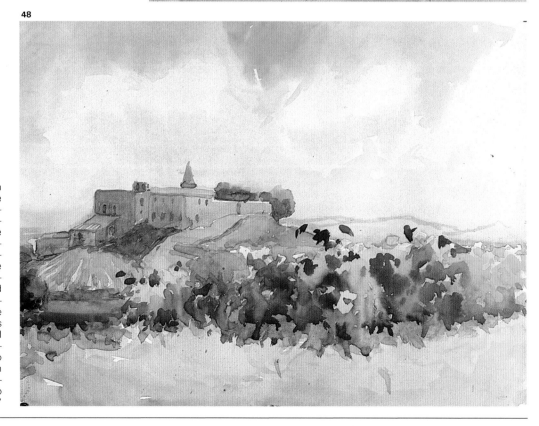

Fig. 48. Here in the fifth phase we can see that the third dimension is enhanced through the contrasts created between the foreground and the background planes; dark intense colors and definite forms are used in the foreground, and diffuse and muted forms in the background. "For me it's like an obsession," stresses Gaspar Romero. "While I am painting I am constantly thinking about how to create the effect of depth by intensifying and contrasting the foreground to make it stand out more."

The fifth and sixth phases

The fifth phase: intensifying the constrasts

Gaspar Romero keeps working on the central area steadily—without pausing, but without rushing either—starting from the left and moving toward the right of the picture. The first really dark strokes to appear are those of the thick burnt sienna of the vines. They add considerably to the sensation of depth, or relief, and at the same time accentuate the color contrast.

During this stage of painting—the stage in which the background is already finished and the middle ground of vines is on its way toward completion—we see that Gaspar Romero has painted over the general layer of warm yellows, ochres, and oranges with sienna, sepia, and touches of light oxide red in both wet and dry watercolors to draw the leaf clusters and define the vine structure. He also adds a series of greenish smudges of olive green to represent the empty spots or dark areas between the vine trunks and the earth.

The sixth phase: beginning to finish

Here we are. Gaspar Romero begins with the earth in the foreground. In this case we're dealing with the fairly homogeneous tonalities of earth colors, but even so, it's interesting to note that at no moment does Gaspar Romero paint the area in one uniform, even, unvarying color.

On the contrary he tries to diversify the tones. He does so by using a little more or a little less color—first sienna, next sepia, then a little light oxide red—or by adding or taking away a bit of water. "This is something that all beginners should take into consideration the necessity to enrich areas that are basically monotone."

Like most watercolorists, when it comes time to paint large areas of similar shades, Gaspar Romero leaves behind small openings or blanks through which you can see the previous layer of color or the white of the paper. If there's one thing that he tries to avoid, it's precisely "filling the picture too much," finishing it too completely.

Fig. 49. At the end of this sixth phase the watercolor is practically finished. This is the moment to scrutinize it and evaluate what has been done, to analyze the forms, contrasts, and colors.... Gaspar Romero ponders and finally comments in a low voice as though he were thinking out loud, "Pretty good in general, but the sky... the sky could use a bit more color."

Fig. 50. He uses absorbent paper towels —referred to as "kitchen" paper towels— to dilute outlines, mute colors, and "open" spaces.

49

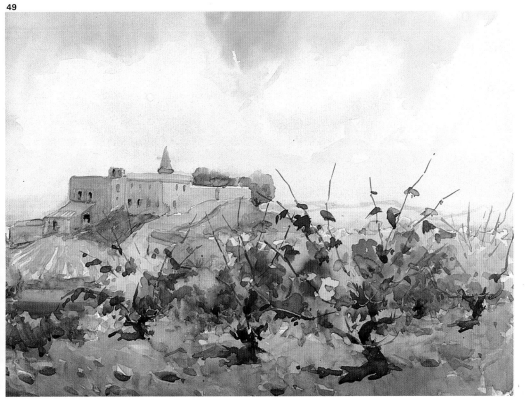

50

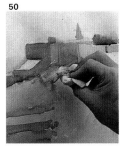

The seventh and last phase

Gaspar Romero produces a greater feeling of spontaneity by using brushstrokes with varying degrees of paint that give different intensities of color and leave small blanks or "holes."

Burnt sienna, sepia, and ultramarine blue are used for the dark color of the trunks. We must emphasize that Gaspar Romero sometimes interrupts his painting to wait for the painted areas to dry before painting on top of them.

Now he paints the vine shoots. He uses a broken, rather than continuous, line to capture this part of the vine. Gaspar Romero primarily uses his brushes and an absorbent paper towel to pick up any excess water or color, but every once in a while he also employs his fingernail to open up white spaces or to indicate a clear stroke on a dark ground. As previously mentioned, in our discussion about materials, a beveled brush handle can be used to achieve the same effect. In any case—whether using your fingernail or a brush handle—you have to work with a damp layer of color for this operation to be successful and to uncover a light area or the white of the paper.

The usual procedure for opening up a clear space in a dark area is the following: wet the area, press the brush dry, then absorb the water from the wet area with a brush or an absorbent towel. When you absorb water you take color with it and thus leave the paper white again. Then of course it's possible to paint a new color, a new form, or a new contour over this blank area. Needless to say if we want this overpainting to be clean, precise, and clear cut, we have to wait for the "emptied" spot to dry.

When is a picture finished? Some painters would say that there's still further to go, others would consider it completed. As we can see the exact, precise strokes of the building windows and the vine trunks are the darkest touches of the picture right now. Gaspar Romero thinks that the foreground could use a little touching up, too.

He goes to it.

The finishing touch

Watercolor always implies a certain amount of risk, but today Gaspar Romero has decided to risk it all. There's something about the picture that he just doesn't like.

He contemplates his work and decides that he wants to modify the sky.

51

He turns the paper completely upside down so that the sky is on the bottom—the world gone topsy-turvy—and begins to execute a very daring modification (Fig. 51). He mixes a new cobalt blue, one that is slightly grayer and deeper in color. The upper portion of the sky is progressively darkened with special attention given to its left side (currently to our right since the picture is upside down). The shapes of the clouds are slightly changed in the process as well.

The artist turns the picture right-side up again. He's fairly satisfied with the result. What has happened? Not much, but the watercolor looks different somehow. The darkness of the earth in the foreground is now counterbalanced by the darkness of the sky at the other extreme of the picture. This has the effect of highlighting the central zone, giving it more depth and light.

Now all that's left to do is to sign the work. Gaspar Romero does exactly that.

52

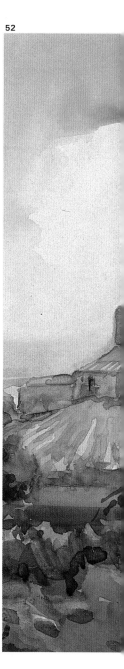

Fig. 51. To give the landscape a finishing touch, Gaspar Romero decides to deepen the color of the sky. To do this, he turns the watercolor upside down so that the blue wash of the sky will remain lighter near the clouds and darker at top.

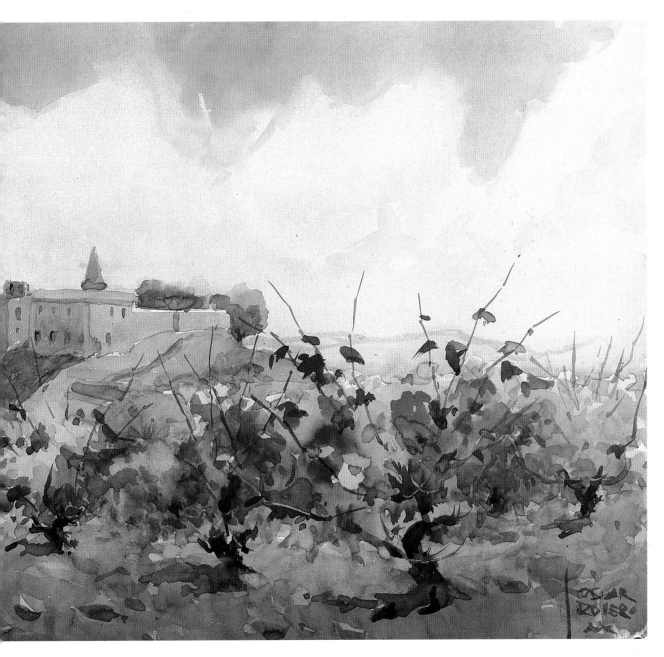

Fig. 52. The finished project. If we were to summarize the characteristics that make Gaspar Romero's work outstanding, we would list the following: 1. An enviable richness and harmonization of color obtained by a constant, careful variety of tones and hues within a well-planned range of warm colors. 2. Successful portrayal of depth through the highlighting of the foreground hues and colors (the vine trunks, the closest leaves) against a grayer and more diffuse background (the buildings, the trees behind the buildings, the very distant background mountains). 3. The general spontaneity in the execution of the painting. Notice the small ''holes'' or white spots that Gaspar Romero has left behind from the beginning to the end of the painting process. The layering effect of these blanks and light areas leave the final phase of the painting with a distinct color vibrancy, vitality, and realism of subject matter. The watercolor remains fresh and spontaneous, thus illustrating two of the most prominent qualities of the medium.

Fresquet chooses a subject

One cold winter morning we leave behind the big city and go to paint outdoors with watercolorist Guillem Fresquet.

Fresquet is a seasoned watercolorist, prestigious both in and out of Spain. During his lengthy career as an artist he has won many prizes and has participated in numerous exhibitions. "I just got back from Valencia, where I inaugurated a new one," he tells us.

"I like that over there," he suddenly exclaims, pointing to the left. The driver hits the brakes and we get out of the car.

Selecting a subject

The painter examines the landscape: trees, meadows, an old rustic house, a modest river with a small waterfall.... Fresquet walks from one spot to another, he looks here and there, he moves all around the possible motif. He's already making a mental "picture" (Figs. 54 to 56).

At this stage the artist does much the same thing as a movie director would do trying to find a good set for his movie. The problem is not so much one of *what* to paint or film as one of where to set down the camera or the easel and artist. In other words *from where* to paint.

Fresquet vacilates between painting against the light or with the light.

"Against the light is easier. If the motif is lit from the front or the sides and there are a lot of light areas, you have to be very careful to reserve a lot of white blanks. The contrasts are softer and easier to paint if you choose something that has the light coming from behind it."

Finally the artist decides to paint against the light.

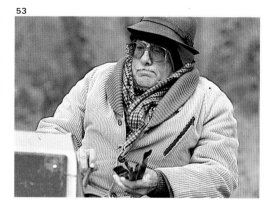

Fig. 53. Guillem Fresquet painting a watercolor landscape on a cold winter day, a landscape we will take time to study closely. Fresquet is one of Spain's most prominant watercolorists who is well known in Europe and in the Americas; he has won many prizes and has exhibited his work all over the world.

Figs. 54 to 56. Fresquet tries to find and select a motif for a watercolor painting. He has meandered to a small mountain river and is examining the small waterfall in front of him. "Like the impressionists said, there are really subjects everywhere," he says. "Cézanne was right when he said that when you are in a place like this you have one picture in front of you, another picture to your right, another picture to your left..." Fresquet continues to walk along the riverbank with his back to the sun, until he suddenly swings around and studies the landscape with the light facing him. "When you're in a place like this, next to a river with lots of vegetation and trees," he comments, "it's always better to have the light against you: The reflections on the water, the shadows of the trees, and the tree trunks against a foggy-gray background always make for a good picture."

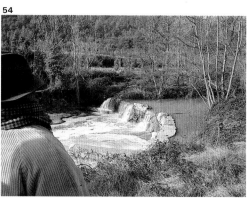

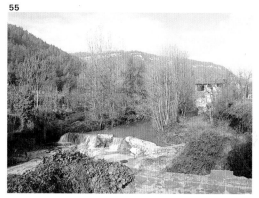

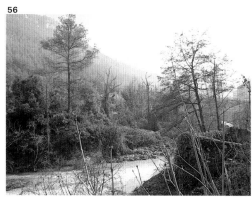

The works of Fresquet

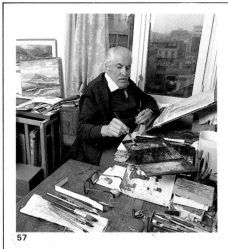

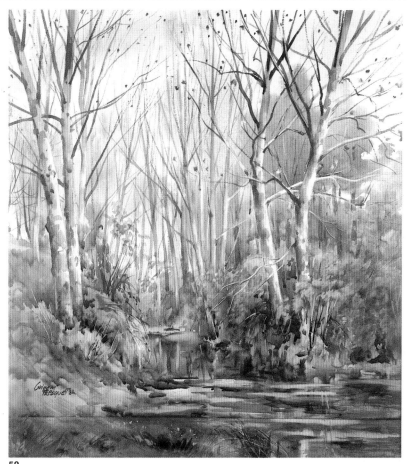

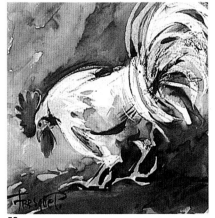

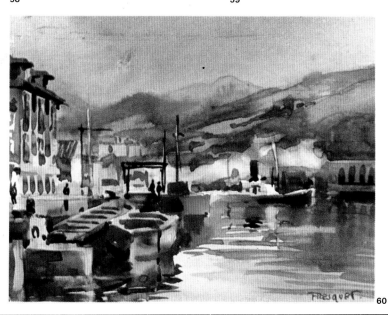

Fig. 57. Here is a photograph of Fresquet working in his studio.

Figs. 58 to 60. These paintings show Fresquet's great skill as a water-colorist. They illustrate the wide variety of subjects that he is capable of depicting: landscapes such as the difficult and time-consuming one above, human figures or animals such as this masterfully captured rooster, and atmospheric scenes such as this harbor scene.

Materials for watercolor painting outdoors

"This has to be simplified; that is, trees, bushes, branches, and some of the background shapes have to be eliminated," the artist comments on his subject. "When you paint with the light against you, all you have to do is keep adding color, making it a little darker each time. And simplify it. That's all (Fig. 61).

Fresquet holds up a black cardboard frame, which comes in handy when selecting a composition from a general view (Fig. 62).

"Sometimes when the composition isn't too clear, it's useful to make a small sketch."

Quickly, with a blue marker, he makes a sketch: He outlines some shapes and places the elements on the page—in other words, he composes the picture (Fig. 63). The artist isn't going to have this sketch in front of him when it's actually time to paint, however. He puts it aside with a firm gesture. It was merely an intellectual exercise to see if he could capture on paper what he had to work out in his head.

Equipment for watercolor painting outdoors

Fresquet always works sitting down. He doesn't use an easel; his easel is his open watercolor case, on top of which he places his pad of paper. He leans the pad against the lid of the case.

"What kind of pad or paper?"

"A medium-grain Fabriano if you want to open up white areas, although Schoeller is better for bringing out purer whites," Fresquet replies. He also comments that, as we have already seen in the work of Gaspar Romero, there's a difference between opening up white spaces and simply reserving them. Fresquet explains that he doesn't care for white areas that are too white or "clean."

The block of medium-grain paper that he works with measures approximately 18 inches × 24 inches (45 cm × 60 cm).

Now Fresquet prepares his colors. He prefers watercolors in tubes, creamy watercolors. He doesn't like pan watercolors. He uses the same metal palette box, with white

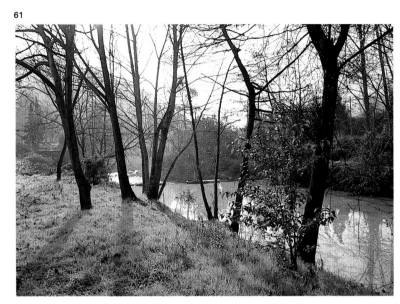

61

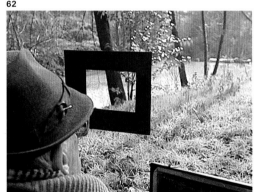

62

Figs. 61 to 63. Fresquet is studying how to best frame the landscape he has chosen as his subject by looking through a black cardboard frame. He then makes a rapid sketch to reaffirm and fix in his mind the picture that the sees —the landscape as he chooses to interpret it. As you can see in Fig. 78 on page 37, his finished landscape differs from the actual subject in front of him.

63

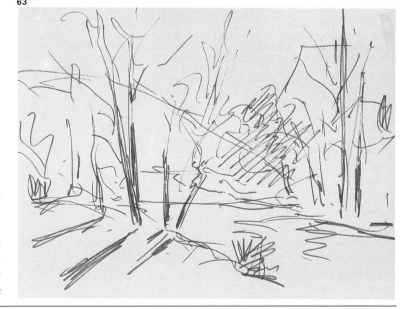

64

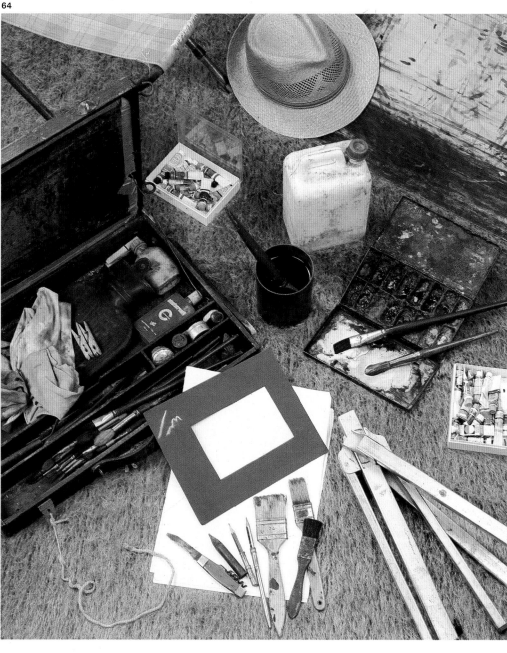

Fig. 64. These are the materials and equipment that Fresquet uses when he paints outside of his studio: a palette box with compartments for various creamy tube watercolors; numbers 9, 12, 14, 18, and 22 brushes; a flat brush for painting background wahes; a plastic bottle and a plastic container for holding water; absorbent paper towels; and a carrying case to transport paper, pencils, and so on. Of course, when he goes out painting, he goes by car.

enamel compartments, outdoors as in the studio. He never cleans it because according to him the resulting dirty grays help him harmonize his colors. Nor does he clean out the color compartments, so each one contains dry remnants of previous painting sessions. The artist limits himself to filling each compartment cavity with new color pressed from the tubes.

He mainly uses round sable-hair brushes, usually numbers 9, 12, 14, 18, and 22; a number 16 flat brush for backgrounds and broad washes; and round numbers 1 and 6 for making very thin lines or strokes.

Fresquet fills a plastic container with regular tap water. He adds a little sugar. "So that the color will look a little brighter," he says.

The first and second phase

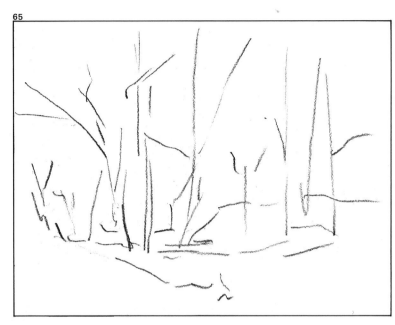

The first phase: a pencil sketch

With a white sheet of paper in front of him, Fresquet begins to draw with a regular pencil. He sketches firmly and rapidly.

As you can readily observe, we're dealing with a very basic draft that has even fewer lines in it than the previous sketch that the artist made with a blue marker. They are, however, very precise and crucial lines; the verticals indicate the trees and the horizontals suggest the background mountains and the riverbanks. It's a mnemonic device to help the artist remember what has to be done.

"Yes, the sketch only serves as a guide and nothing more. I could have done it without any previous drawing, too."

The second phase: the sky

Fresquet dips the flat number 16 brush into water and resolutely starts to paint the upper left-hand side of the paper with a brownish gray made with a combination of madder, ochre, and a bit of blue (Figs. 66 and 67).

He adds blue as he beings to paint the upper right-hand corner, corresponding to the cloudless section of the sky, but it's still a very light and muddy tone, totally dirty and uneven. He increases the amount of madder in the color mixture and starts painting in the two distant riverbanks slightly lower down.

Next Fresquet wets his brush, loads it with brown, then with blue, and shades in the mountain area with a gray that's almost black but nonetheless very pale because of the high water dilution.

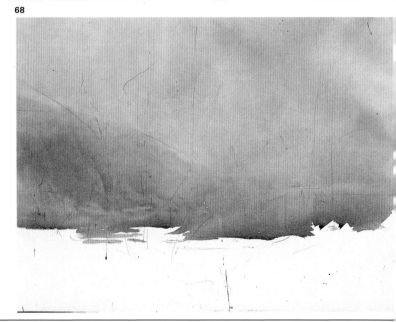

Fig. 65. Fresquet draws a very schematic sketch, a totally freehand interpretation of the landscape that he has in front of him, that nevertheless anticipates the shapes, placement, and composition of the final watercolor. Compare the photograph of the actual landscape (Fig. 61) with its interpretation in this sketch and in the final watercolor in Fig. 78 on page 37.

Figs. 66 to 68. In this second phase we can see the process followed by Fresquet in painting the background, the most distant planes, and the sky. Due to the use of the wet-on-wet watercolor technique, the color of the sky blends with the grayish forms in the background.

The third phase

69

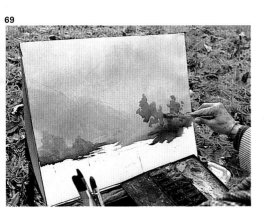

70

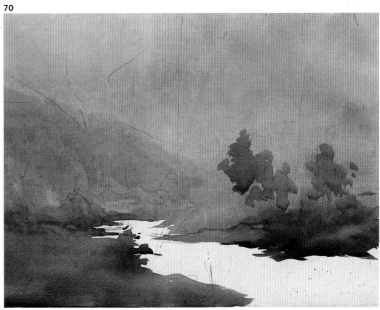

Getting the shapes down

Fresquet selects the filbert, or cat's tongue, brush out of all the brushes that he has in his left fist. With it he jots down the shapes of some trees next to what will be the right bank of the river.

Switching to a flat brush, he begins to paint tones that are almost bright and clean, and then, with the same brush, he blends them. This kind of brushwork is characteristic of watercoloring.

The riverbanks are beginning to take on form. Only the river-to-be has been left totally white.

Logically enough, green increasingly predominates: a very dirty green in the riverbank and a slightly cleaner one in the meadow in the left-hand foreground. But this green quickly blends in with the other brownish earth tones. As soon as he applies color to the lower part of the picture, Fresquet absorbs the excess water in certain areas with a dry, or almost dry, flat brush, thus leaving noticeable "spots."

Only the area of the paper that will be the river is left white. It's already possible to *guess at* the final format of the painting because the forms indicate that there is, for example, a riverbank and bushes.

But besides this, the indeterminate space of the previous phase has taken on a new meaning. We see a zone corresponding to the cloudy sky, an area representing the blue sky, and the distant foggy mountain to the left.

71

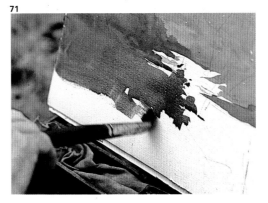

Figs. 69 to 71. In these three images of the third phase we see how Fresquet paints the riverbanks with a technique somewhere between drawing and painting. With great surety of hand and total reliance on his instinct and experience, he approximates where to leave a space for the luminous river and blends in the colors of the trees and forms of the middle ground using the wet-on-wet technique.

In other words, the harmonized diluted tones that initially seemed more appropriate for an abstract, rather than figurative, painting have nonetheless become figurative at this stage.

"It's taking a long time to dry because it is so humid," comments a slightly annoyed Fresquet.

The sun has let us down. It was shining when the session started, but is covered by clouds now. "But that doesn't bother me in the least," our man says smugly, "because I have the picture in here." And he points to his head.

The fourth phase

72

Fig. 72. Fresquet paints the trunks of the trees using a thin long-haired number 6 brush (Fig. 74). In this photograph observe how Fresquet holds his brush by its very end. "This allows you to paint further away from the picture and get a better view of it as a whole," says Fresquet.

Fig. 73. What Fresquet paints is actually a synthesis of the subject, his own interpretation of the forms, colors, and contrasts. In this fourth phase he very successfully depicts the third dimension thanks to the contrast of forms and colors achieved by the foreground.

73

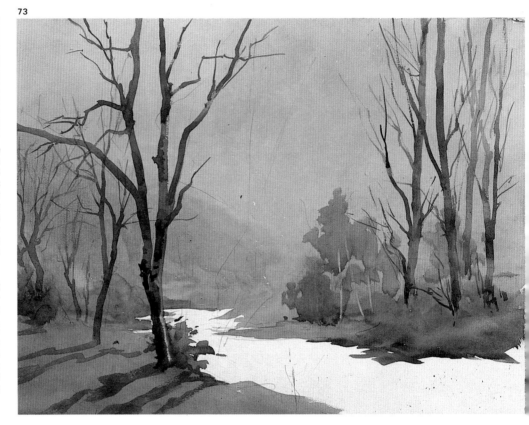

74

Volume and vertical shapes

The time has come to see why the sketch lines were drawn.

Definite shapes of trees begin to emerge. Fresquet sometimes uses his finger to blur the shapes that stand out too much, as if he were painting with chalk.

Then he outlines a tree in brown, and immediately uses sap green to indicate the tree's shadow on the grass. After applying the color, he continues to use the dry flat brush to open a couple of whites in the left foreground tree by brushing vigorously over the wet watercolor.

It's a very rapid process. He gets colors out of the compartments, mixes them on the palette box cover, applies them to the paper, looks at the landscape, gets some more color, mixes it again, paints a little bit more, looks again. He does it in less time than it takes to describe.

Do you remember that at the beginning Fresquet said that it is necessary to "clean up" the picture, meaning that it is neces-sary to simplify or eliminate any extras? We're seeing this cleaning up in action. Compare the two riverbanks, the meadow, and the trees you see on this page with those in the photograph in Fig. 61 on page 30. You'll see that the process has begun; the artist has synthesized his own reality from the hodgepodge in front of him.

Fresquet traces the branches of the trees with a round number 6 brush. It's a very long-haired, very flexible brush with a thin point (Fig. 74). "It's a good one to use because it allows for very rapid hand movements," he says.

A certain feeling of depth or relief is coming into being. No longer is it only a question of space, but also of volume. In the background we have the original diluted colors. In the middle ground of the right riverbank and the foreground of the left bank, however, dark tones and colors are beginning to emerge alongside the vertical trees.

The fifth phase

75

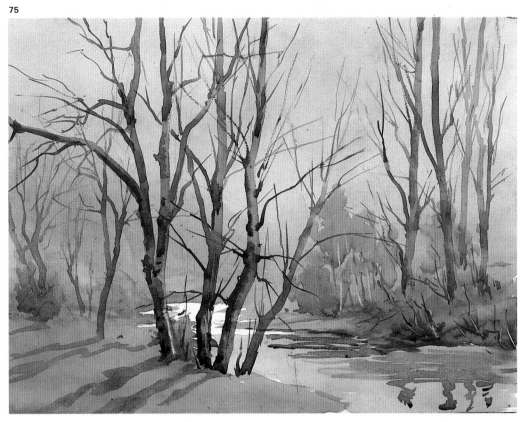

Figs. 75 and 76. Here, in the fifth stage, Fresquet plays with details. He adds clear color to the trunks of the trees, draws in the small branches of the trees with a very thin brush, "draws" clear strokes by scratching with his nail (Fig. 76). "In order to be able to open up these light strokes with your nail, the color has to be recently painted and still wet," Fresquet warns.

The water and trees

Fresquet changes brushes; now he picks up a number 18, wets it, dips it into an ultramarine blue which he then adds to the color already in his palette, stirs, picks up some Prussian blue, and stirs again in search of the perfect hue.

Every once in a while the artist rubs with his fingernail to open up small white openings in a recently painted area. If what he seeks is a somewhat light tone, he only scratches once lightly. If he wants a white—a white that is slightly dirty, the way he likes it—he uses the same fingernail or another one a little more forcefully. Sometimes he uses his fingernail to rub off color in a wet area and applies it to another, not so wet, area of different color.

Now he returns to work on the vertical shapes, namely the left-hand side of trees. Soon there are four trees where a moment ago there was only one. It looks as though the artist has repented having "cleaned up" or pared down the lines so much. This new

76

77

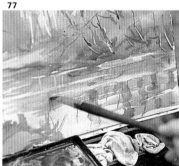

addition changes the equilibrium of the composition. It fills the central zone with vertical lines that take away the artificial theater-backdrop look that the picture previously had; the foreground and background were much too distinct, as though they were two marquetry cutouts.

You "do everything at once" in watercolor. Fresquet works very quickly: He extends the color, blends it, draws a branch unfalteringly, looks at the landscape, gets more color, mixes it, extends it again.

Fig. 77. Next Fresquet opens up white areas of the reflections in the river. "Wet the zone lightly, wait a little, and then before it dries, rub and absorb the color with a completely dry brush."

The sixth and last phase

Darker, more defined tones and colors begin to appear in this stage. Working a bit more slowly now, the painter gives depth to the trees by capturing the play of light and dark on each one and enhancing the texture of the trunks. If we want to continue the parallel we drew earlier to cinematography, we can say that Fresquet establishes the picture's depth of field with this foreground.

Meanwhile, of course, he continues to rub his finger over the newly spread colors and open up light strokes with his fingernail.

Fresquet starts on the reflections of the water, a somewhat complicated part of the picture. For the time being it only consists of some horizontal dark gray brushstrokes over a lighter bluish gray. This is the moment when the artist decides to take a break. He gets up, walks around his landscape for five to seven minutes, and then sits back down and starts painting again.

Now the painter uses a flat brush to "dry" watercolor the reflections onto the water with a minimum of paint. To his right he has a used rag in which he periodically dries his brush. He also shakes the brush, letting the excess water sprinkle onto the grass.

He resolves the problem of the small waterfall at the farthest part of the river with light touches of an almost completely dry brush that makes the white of the paper reappear. The picture is nearing completion.

The final details

The advantage that the painter has over the photographer or the movie director is the ability to change reality to suit his or her liking or convenience. In this last phase—the phase in which the details that create the impression of depth are added—the artist can employ diverse strategies.

Right now, take a look at the painter's interpretation of the foreground, the left bank where he is sitting. Notice that the green here is much warmer than the green of the opposite bank. This is one of the strategies: vivid and warm colors for objects nearby, paler and cooler colors for distant objects.

Another procedure for obtaining depth is to paint what is close by with darker and clearer colors, to give it more contrast. This is what Fresquet has done with the trees on the left bank. They are "drawn" in much greater detail and stronger colors than those of the opposite bank.

The last procedure or strategy is dilution or diffusion of the background.

The artist has taken two hours to complete this painting. Completion time varies a lot, depending on the subject matter. "This one has been an easy picture to paint," says Fresquet. It's a winter scene, a cool landscape of soft contrasts that is lit up from behind, but Fresquet insists that he also likes to work with strong, bright daylight contrasts. "The outcome depends as much on how the artist feels that day as on what the landscape looks like and what it suggests to him," he adds.

The last details give the work its finished aspect. Some leaves in the trees, some more shadows on the trunks, a few fallen leaves on the green meadow: little touches here and there that don't modify any of the basic structures.

In this final phase of work, very thick colors—in terms of watercolor, that is—alternate with very diluted strokes, such as those used in portraying the water reflections, where strokes were used to actually remove color or open up areas.

Fresquet explains that although the painter decides outdoors whether the picture is finished, he may later view it differently in the studio and modify it further. Just in case, he places the watercolor about 7 feet (2 m) away and studies it carefully. Then, finally, he signs the picture.

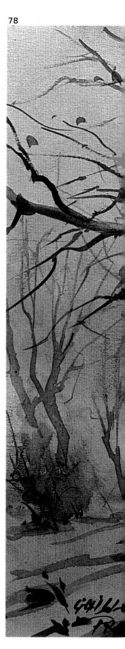

78

Fig. 78. Here is the finished picture: A complete watercolor lesson in itself that has touched upon the use of wet and dry watercolor techniques and has given a valuable example of how to reserve spaces from the very beginning in order to structure and model the subject well. It has also provided us with an excellent lesson on artistic interpretation and composition. With its well-defined foreground trees standing against a distant and indistinct background, it is obviously successful in capturing depth. It makes the viewer experience space, air, atmosphere. Congratulations, Fresquet!

Using a sketch and photograph for reference

In the northwest of Spain, bordering Portugal and the Atlantic Ocean, there's a region of blue skies, rich earth, green hills and fields, and white roofs and houses called Galicia. It is a place where the sun shines but there's also plenty of rain for grass, meadows, trees—and everything is pure color and landscape.

I was in Galicia a while ago, painting oil pictures and making watercolor sketches of the landscape. I also took some photographs to make studies of different subjects and settings. Using one of my painted sketches and a photograph taken of the same spot as a departure point, I am going to paint a watercolor landscape here in my studio in the wet-on-wet technique.

Fig. 79. José M. Parramón, professor and artist, will show us in the next few pages how to paint a watercolor using the wet-on-wet technique.

But first let me show you the materials and tools that I use to watercolor. Look at the bottom of this page at the following photos. A few items that would make this list complete, such as a drawing gum for reserving white spaces, India ink for reinforcing outlines, a medium (a liquid that acts as a moistening agent and varnish), are missing. Here I should mention that other artists may use different materials. There are those who prefer wide-ended as opposed to rounded brushes and those who paint with pans of moist watercolor instead of the creamy tube watercolor.

Apart from these slight variations for personal preferences, these are the normal tools of the trade for watercolor.

Fig. 80. MATERIALS FOR WATERCOLOR PAINTING

1. Easel in the form of a book rest
2. Paper mounted on a wooden board
3. Scrap paper for sampling
4. Container with water
5. Rag for absorbing water from the brush
6. Palette box for painting with creamy tube watercolors
7. Sable-hair brushes
8. Stag-hair brush for background washes
9. Cotton-tipped swab sticks
10. Natural sponge
11. Jar for keeping brushes

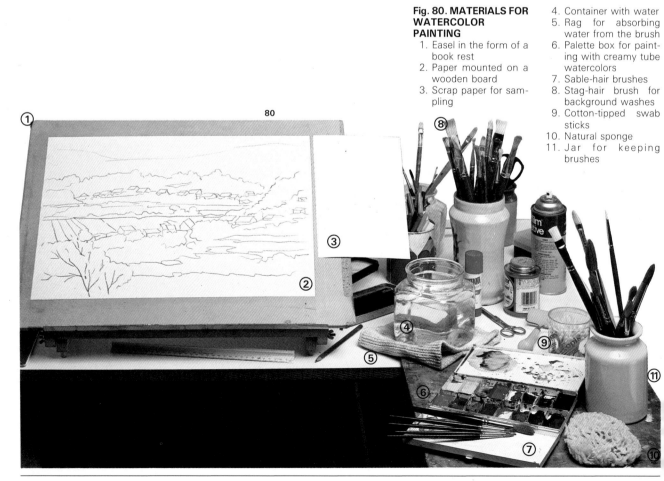

Materials and tools

81

Fig. 81. *Table-top easel in the form of a book rest*. The watercolor paper has to be fastened to a wooden board which must be in an inclined position of about 45 degrees. There is a commercially available table-top easel that looks like a book rest which is perfect for this.

82

Fig. 82. *A natural sponge and cotton-tipped swab sticks*. The sponge is used to wet the paper with water or to paint certain areas with washes of color. The cotton-tipped swabs are used to absorb color while it's still wet.

83

Fig. 83. *Scrap paper for sampling colors*. Many professionals choose to test out colors, tones, and hues on a piece of scrap

paper similar to the one that they are going to be working on, before launching into the definitive painting. At the lower left (Fig. 83) we can see some color samples made by the famous Spanish artist Mariano Fortuny in the right-hand margin of his watercolor painting.

84

Fig. 84. *A variety of brushes*. In principle you need only two round sable brushes—a number 7 or 8 and a number 14. However, two other brushes may come in handy as well: A broad 1½-inch (4-cm) stag-hair Japanese brush that is perfect for wetting areas, and consequently especially useful for wet-on-wet painting, and a broad-ended synthetic number 20 brush with a beveled tortoise-shell handle that can be used to "open" white spaces or blanks in recently painted areas.

85

Fig. 85. *A roll of absorbent paper towels*. This is the same roll of paper towels that you use in the kitchen. It's similar to toilet paper, but spongier and more absorbent. It's essential for absorbing water from the brush, for drying, or for muting the color of a recently painted form, and so on.

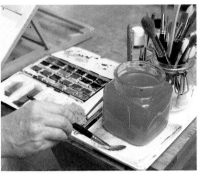

86

Fig. 86. *Watercolors*. I am going to paint this watercolor with creamy tube watercolors but I could have just as well used moist or wet pan watercolors, since they offer the artist almost the same options and give almost identical results. They say that creamy tube watercolors are better for painting large, outdoor pictures—24 inches×20 inches (65 cm×50 cm) for example—because their colors stay fresh and wet longer, thus permitting a very rapid, effective execution of a picture. But I think that it boils down to a question of habit, and that it's just as easy to paint with wet pan watercolors as with creamy tube colors.

87

Fig. 87. *Papers*. They come in fine grain, medium grain, and thick grain. Medium-grain paper is most appropriate for 18 inches×14 inches (50 cm×35 cm) watercolor, and a thick-grain paper for anything larger. Watercolor paper comes in separate sheets or in pads or blocks that are bound on all four sides to avoid any warping or the necessity of mounting.

Equipment for painting outdoors

88

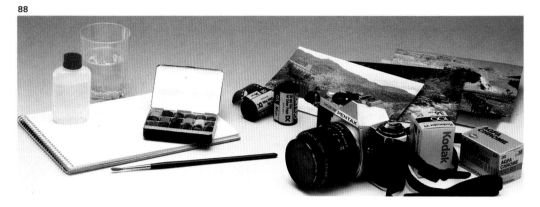

Fig. 88. Kit for painting sketches outdoors, complete with a standard gauge camera for taking photographs of possible future themes.

Fig. 89. Previous sketch painted from nature using the wet-on-wet technique.

Fig. 90. The photograph of the same scene that was used along with the previous sketch to paint a watercolor, illustrating the wet-on-wet technique.

When I'm walking around, looking for subject matter, I almost always carry with me a canvas bag with a small pad of drawing paper, a glass, a water flask, a number 8 sable brush, a small palette box of watercolor, and a 35 mm camera. All this makes for a good sketch-and-photograph-taking kit. Later, in the studio, these same sketches and photographs enable me to select and modify subjects, study various settings, interpret, and finally paint a theme.

Usually these sketches are nothing more than color "notes," but occasionally one of them ends up being a small painting in its own right. This indeed happened during my trip to Galicia.

I was driving down a back road when I saw a landscape that looked good to paint. I stopped the car at a sort of lookout point with a panoramic view—two rows of houses with blue shadows and red roofs on a wide plain full of meadows and trees, with a blue-gray mountain range as a backdrop.

I started drawing the houses with the idea of merely making a color sketch. But since it was early, the subject was attractive, and the weather nice, what was going to be a mere draft ended up being the small (original size 7 inches × 5 inches [190 mm × 130 mm]) painting that you see reproduced on this page (fig. 89). I also took photographs of the same scene from various angles.

Using these materials, this photograph, and this sketch as a point of reference, I am going to paint a wet-on-wet watercolor now.

89

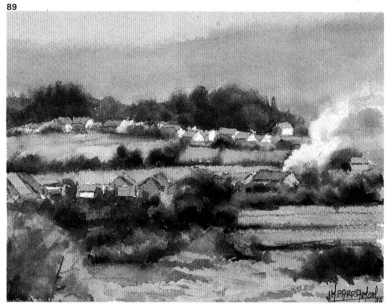

90

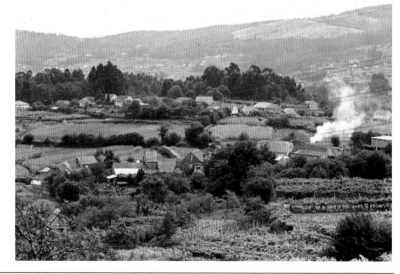

Parramón's work in watercolor: any subject matter is possible

*Watercolor themes painted
by Parramón*

A random visit to any watercolor exhibition may leaded you to believe that watercolor pictures are limited to landscapes and seascapes. It's not so. Using watercolor you can paint any subject be it a human figure, a portrait, a self-portrait, a still life, a wharf scene, or a landscape in either color drafts, sketches, or finished paintings.

91

92

Certainly, outdoor seascapes and landscapes are ideal themes for watercolor interpretation because of their color and luminosity. This freshness and luminosity —which is the result of the rapid execution and reaction time of this medium—can, however, be equally applied to subjects such as the portrait and the human figure. I hope that the watercolors displayed on this page (Figs. 91, 92, 93) will serve to convince you of this.

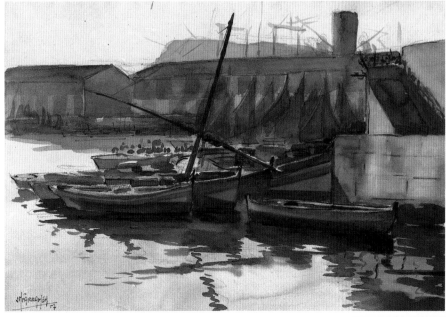

93

With or without mounted paper, the first thing is a sketch

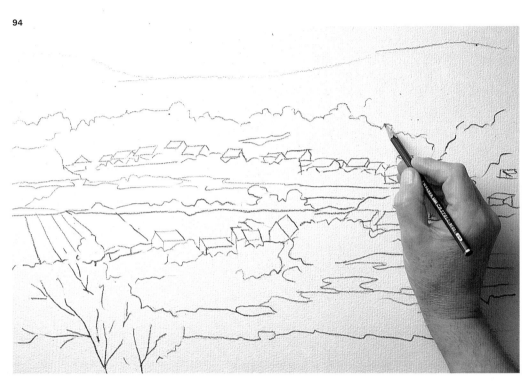

94

Fig. 94. The quantity and complexity of forms appearing in this landscape calls for the artist to work painstakingly in outlining the trees, roofs, and boundaries of the meadows and fields. However, this complexity also offers the artist many points of reference which he can use for calculating the correct dimensions and proportions for achieving an accurate, well-constructed drawing.

First mount the paper, to tauten it. This is not an indispensable step. When working with a thick high-quality paper that resists buckling or wrinkling when it's wet, it's usually enough to fasten the sheet down with four tacks. However, since I am going to be using the wet-on-wet watercolor method the entire time, the paper will be wetted and stretched even more than usual and, consequently, even more prone to the distortion and warping that I want to avoid.

Secondly, "construct" or sketch the model; a somewhat complicated sketch requires careful calculation of dimensions and proportions. This one seems difficult to do because of the sheer quantity and complexity of the houses, meadows, and trees—but it is exactly this quantity and complexity that will guide you in determining the location and correct proportion of each element. In other words, it's easier to paint the face of an old man full of wrinkles than that of a smooth, shiny-faced young boy. You have to start by first drawing the house in the middle of the back section. Once that is done, you can draw in the two rows of houses. From there on, it's easy sailing.

Thirdly, paint wet-on-wet. In figures 95 to 97 of the following page I demonstrate how to use the wet-on-wet watercolor technique by filling in the background of a profile. As you can see this technique primarily consists of first wetting the ground with slightly dirty or tinted water to delimit the area or form to be painted. Next it's a question of immediately applying wet color onto the wet ground so that it dilutes and diffuses softly. The evenness or irregularity of this diffusion is controlled by applying brushstrokes of varying loads of color. Let's apply this technique to painting the background sky and mountains of the Galician landscape.

Demonstration

95

96

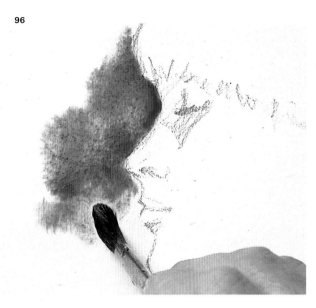

97

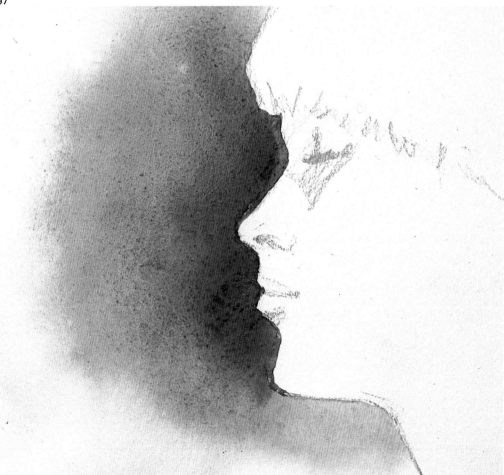

Figs. 95 to 97. Here we have an area painted in the wet-on-wet technique. First wet the area that you wish to paint, starting out from the edges of the contour or profile (in this case the outline of a face). It is best not to use perfectly clean water; that is, it is best, if possible, to be able to see the water that you apply onto the white paper so that you can make sure you see the boundaries of the contours (Fig. 95). Next apply the chosen color to the wetted area. The color should be applied to the part that you want to be darkest in color (Fig. 96). The water then runs and diffuses the color further, thus creating the interesting and sometimes unexpected effects characteristic of wet-on-wet painting.

Painting the sky upside down on a separate sheet of paper

Figs. 98 and 99. To give you a better understanding of the wet-on-wet technique, I have reproduced the section of the painting with the top of the sky, the mountains, and the cluster of trees just above the most distant row of houses on a separate sheet of paper. As you can see in Fig. 98 I start the demonstration by turning the picture upside down and apply a wash of carmine-pink color just ''above'' the roofs of the houses, making sure not to wet past the outline. Notice that besides painting the sky, I also paint the zone corresponding to the trees. Then, while the pink wash is still wet, I immediately paint another wash of ultramarine blue over it; it blends with the pink to make a blue-purple-gray color, appropriate for the background mountains. While applying this last wash, I work with the board inclined and then move it to a horizontal position to allow better fusion between the two colors along the top edge of the mountains touching the sky. This blending or bleeding is one of the effects of the wet-on-wet technique.

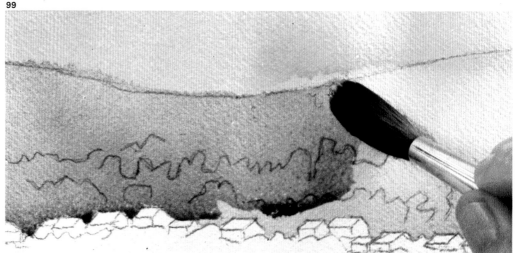

I begin this watercolor demonstration by applying a mix of carmine and pink to the uppermost edge of the sky, above the outline of the row of houses. Notice that in the picture detail shown in figure 98, I am painting with the picture placed upside down; this way the carmine-pink wash flows downwards, making the top of the sky darker. Also notice that not only do I paint the sky with this first layer of color, but also the background mountains and trees.

Then, as you can see in figure 99, I apply a wash of ultramarine blue over the pink. Now I am working with the picture right-side up again. See how the ultramarine blue blends with the previous pink to give a blue-purple-gray hue suitable for the color of the background mountains. To achieve an effective diffusion of color between the mountaintops and the sky, I held the board at a horizontal position while applying the layer of ultramarine blue.

Now I go back to the actual watercolor and paint the houses and the meadows with initial washes of medium bright colors. I try to cover the white paper and eliminate any false contrasts. Figure 104 illustrates what the picture looks like at the end of this first stage.

Demonstration continued

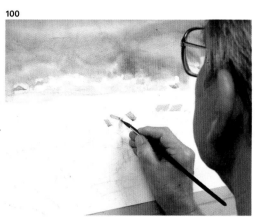

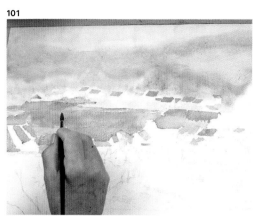

Figs. 100 to 104.Now I stop the demonstration and continue with the actual watercolor. I paint the colors of the houses, fields, and meadows with an initial, tentative wash to avoid any false contrasts later. You can study the process in the photographs on this page. The last photograph shows you what the painting looks like at the end of this first stage.

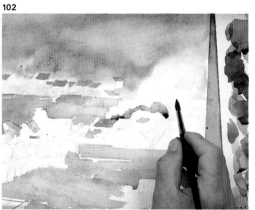

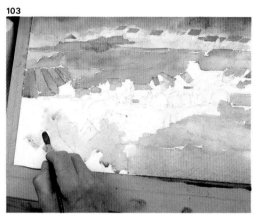

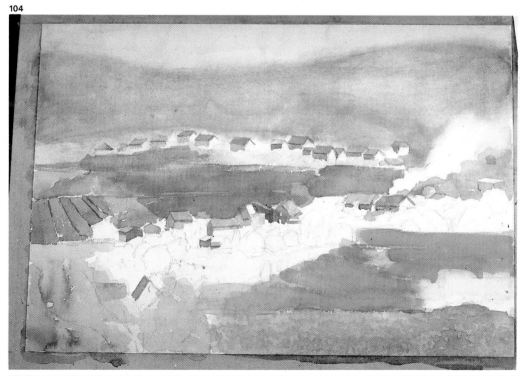

Wet-on-wet painting of trees on a separate sheet of paper

Figs. 105 and 106. Next I paint the most distant group of trees by wetting that area and testing it with a brushstroke of color.

Figs. 107 and 108. Now I go back to the separate sheet of paper to continue the step-by-step demonstration. I apply green watercolor over the previously wet area, carefully controlling the edges (A) of the wet-on-wet effect. It is sometimes necessary to retouch the contours with an absorbent paper towel to get the right final effect.

105
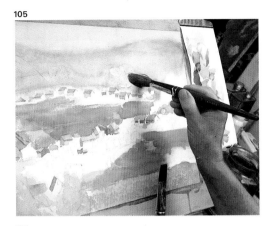

106
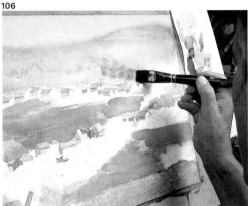

107
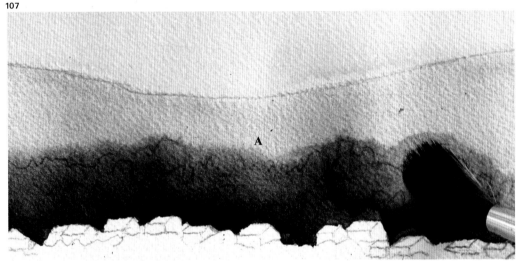

A

108
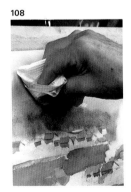

Let's go back to the background—the mountain and the trees—so that I can show you how to apply the wet watercolor technique to the trees step by step.

I begin by wetting the zone or strip of trees with water. In this first step it is important to wet the paper only down to the edges of the roofs and leave the row of houses untouched (Fig. 105). Next I sample a few brushstrokes of the green I have mixed for the trees. Color sampling is a good idea; because of the large quantity of water used in the wet-on-wet technique, colors often lose much of their brightness by the time they dry (Fig. 106).

Now I go back to the separate sheet of paper to continue the step-by-step demonstration of how to paint these trees using the wet-on-wet technique.

You can see the process in the following figures: (Fig. 107). I paint on top of the wet strip of trees with a mixture of warm green, emerald green, Prussian blue, and ochre. I work with the board at an incline and control the amount of diffusion at the top of the trees with my brush (Fig. 108). A paper towel is used for some retouching (Fig. 109). I wait until the previously painted layer of green dries, and then I paint in the shadows of the trees with a darker green—the previous green mixture with blue and Payne's gray added to it (Fig. 110). Now I quickly use a cotton-tipped swab stick to absorb color, to "open" lighter spaces, to dilute and soften colors, to paint in the effect of light and dark on the trees (Fig. 111). I finally touch up this part with a brush dipping.

109

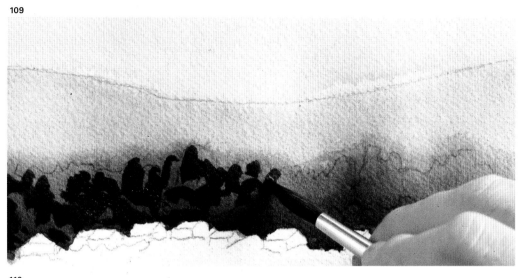

Figs. 109 to 111. The next step in the process is to let the layer of green color dry and then paint in the shadows of the trees (Fig. 109). Right away, while the color is still damp, use a cotton-tipped swab to "open" clear spaces to mold the form of the trees (Fig. 100). Finish this modeling process by touching up the effects of light and dark with brush and water; first wet the area, then wring your brush dry and use it to absorb color and "open" more spaces. (Fig. 111 shows the finished demonstration on the separate sheet of paper.)

110

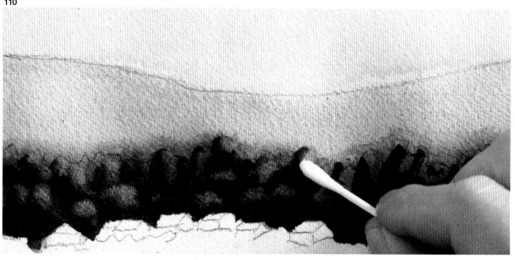

111

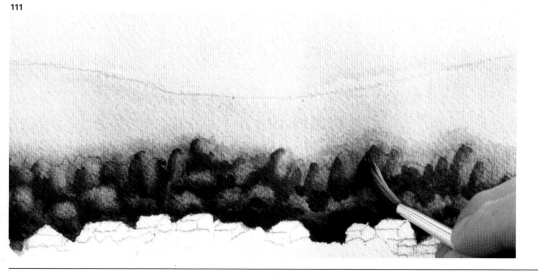

Brushes, cotton-tipped swab sticks, and paper towels

Figs. 112 and 113. In these images you see the cotton-tipped swab stick and brush being applied to the rewetted background trees of the actual watercolor to give them a finishing touch.

Fig. 114. This is what the watercolor looks like at the end of the phase in which the sky, mountains, and background trees are painted in.

This is a painstaking technique, one that requires you to work bit by bit by wetting, painting, intensifying, softening, absorbing, and opening up clear spaces in dark areas. It also requires you to alternate the use of the basic number 7 and number 14 sable-hair brushes with cotton-tipped swab sticks and paper towels, in order to harmonize or lighten shapes. Sometimes when you apply color to an already wet area, you want it to spread, but then you still have to control the edges and the outlines of its flow with cotton swabs, paper towels, and brushes. A clean brush that is still damp, but has had excess water squeezed out of it, can act as a small sponge in absorbing water, taking away color, opening "light" spots, or "painting" light forms.

112

113

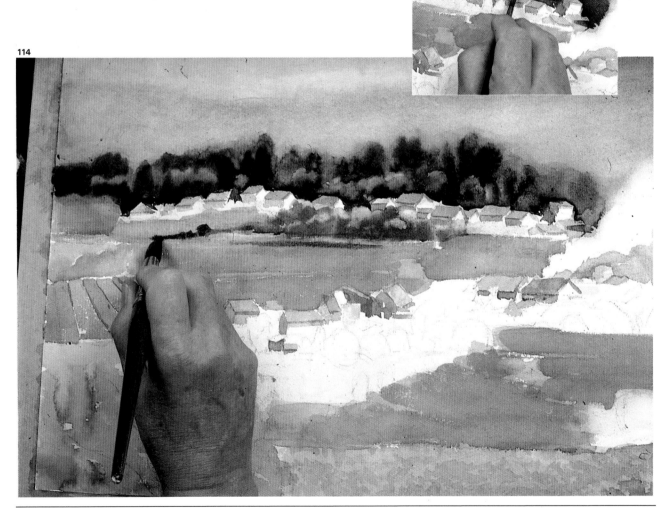

114

Creating contrast with color

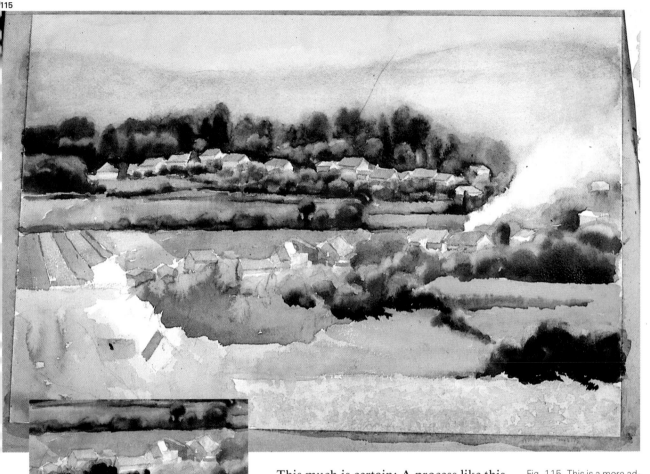

115

116

117

This much is certain: A process like this, which involves painting many small forms, requires you to work each form one by one, as illustrated in the photographs on this page.

As you can see, during this phase of painting, I have deepened the color of the meadows to what will almost be the final definitive colors and have thus balanced out the contrast between the meadows and the lines of houses, trees, and shrubs. At the same time I've tried to create depth by accentuating the color contrast in the shapes in the foreground more than in the middle ground and background. In trying to portray depth I've also taken into consideration the idea of "close colors and distant colors" by giving the foreground greens a yellower tone and the background greens a bluer tone.

Fig. 115. This is a more advanced phase in which the houses, roofs, and smoke coming from one of the right-hand houses have been given more color and contrast. These effects were possible because of previously reserved white spaces for the houses and the smoke; it's necessary to plan to reserve such spaces in all watercolors —and especially in one as complicated as this one— in order to achieve good results.

Figs. 116 and 117. Once again you see the process of painting forms and modeling them, using the wet-on-wet technique.

Enhancing the planes with ochres, yellows, and blues

Figs. 118 and 119. In these images you can see how the painting of the trees follow the general watercolor corollary of going from less to more: first the trunks and the branches; then the foliage and its volume; then the effects of light and dark on individual clumps of leaves, the leaves themselves, and so on.

118

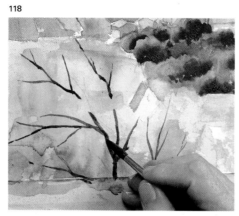

119

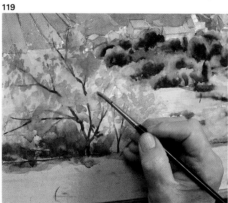

120

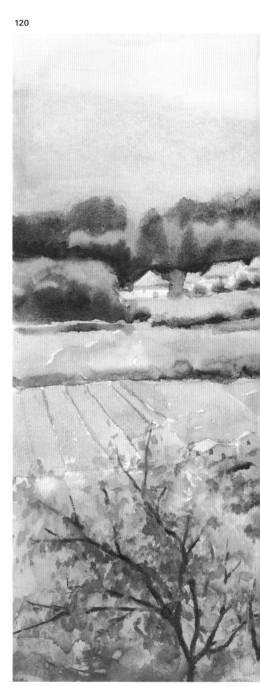

Notice how the center foreground trees are "built up," painted over a background of yellow ochre with a dark green made from Prussian blue, ochre, and dark sienna (Figs. 116 and 117 on the previous page). Once this group of trees is completed it becomes obvious that it's also necessary to darken or reinforce the coloring of the houses and their roofs. And this is precisely what I am going to do next in the final stage of painting.

I have initiated the last phase of painting by touching up the shapes and planes of the foreground. First, the left-hand tree—the trunk and branches with sepia and Payne's gray, and the cluster of leaves with ochre and sienna and sometimes with ultramarine blue mixed in too (Figs. 118 and 119). Next I work on the closest fields and meadows by sketching and painting in the textures of the lay of the land and its dividing lines, as well as the blue splotches of the vineyard in the foreground.

At this point, when the picture is all but finished, I leave it facing the wall until the following day. It's a good idea to do this because you will be able to use a more discerning criteria when giving it the final finish the next day.

In this case it is obviously necessary to intensify the colors of the roofs and the

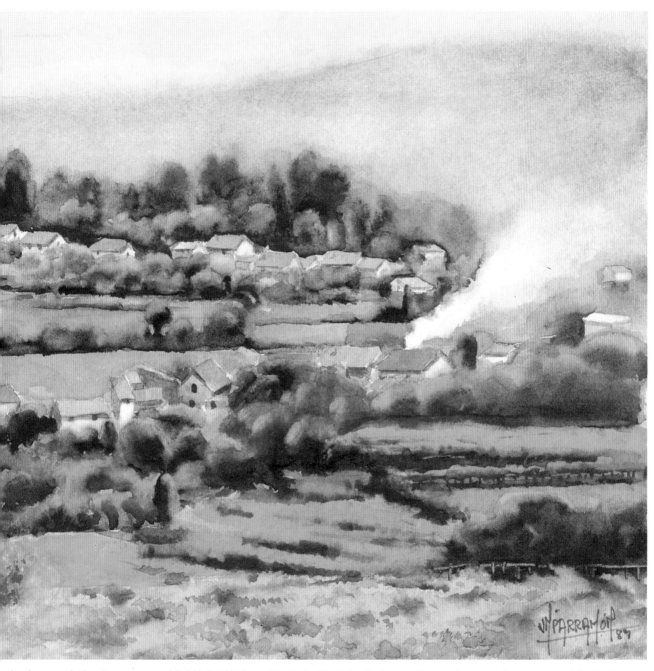

shadows of the houses, to highlight little forms and outlines here and there. It is also necessary to darken the colors of some of the trees and shrubs to compensate for the loss of intensity typical of the wet-on-wet technique and at the same time enrich the contrast and coloring.

Here we have the final result (Fig. 120).

Fig. 120. This is the final result. Besides the effects of wet-on-wet painting, also notice the diversity of color in the meadows and fields, the sharper definition of the trees and shrubs of the middle ground than those of the background, and the application of the "near colors and distant colors" rule in the warm ochres and yellows of the foreground and the bluish colors in the background. All elements work together to create the sensation of depth, or a third dimension. And, finally, by comparing this final version with the previous ones, notice, too, the finishing touches that intensify and strengthen the color contrasts, especially in the roofs and blue shadows of the houses.

An urban landscape painted by Martínez Lozano

José Martínez Lozano is one of the most famous painters of Spain. He paints equally well in watercolor and in oil, displaying magnificent transparencies and washes reminiscent of Sargent and thick chromatic daubs of oil paint seemingly inspired by

Monet's water lilies. Upon seeing his watercolor and oil paintings —some of which are pictured on the next page—it's hard to tell which to admire more, his creativity in composing and utilizing colors or his extraordinary technical skill. Martínez Lozano has exhibited his work frequently and in many countries, and has been awarded more than forty important prizes in different parts of the world.

Martínez Lozano's studio is also one of a kind: It takes up the entire ground and first floor of a house in a small town outside of Barcelona. The entire house, from entrance to its last nook and cranny, is a painter's studio; there are pictures, frames, mounting boards, canvas stretchers, folders, easels, colors, liquid containers, and brushes on all the walls, on the stairway landings... everywhere! On the first floor within the studio proper, the disorder is immense but at the same time fascinating.

"I bought this house with the idea of making it *my* studio," says Martínez Lozano. "Here I do what I want, when I want it, and how I want it."

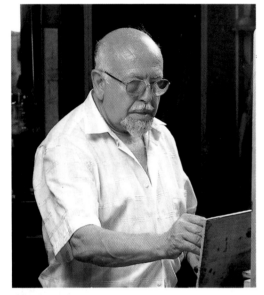

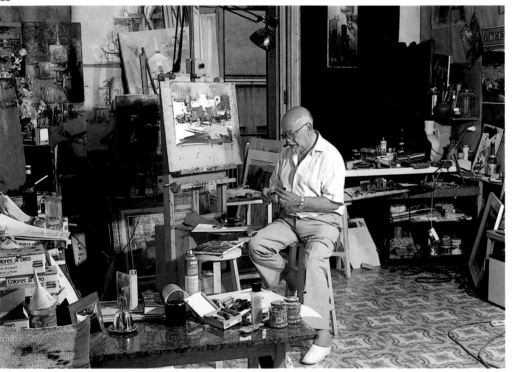

Figs. 121 and 122. Martínez Lozano is a famous Spanish artist known for his landscapes and seascapes, which he paints in both watercolors and oils. He has exhibited his work in various countries and won more than forty prizes. On these pages Martínez Lozano shows us his technique as he paints an urban watercolor scene.

Fig. 123. Martínez Lozano works in a two story house with a ground floor and a first floor. The entire house is his studio. All of the rooms are full of materials, tools, and all the objects typical of an artist's studio. This photograph shows us the room-studio that Lozano is working in.

How Martínez Lozano paints

Martínez Lozano:
an expert creative artist

These reproductions of oil and watercolor paintings offer a sample of Martínez Lozano's extraordinary technical skill and creativity. On the right you see an example of contrast and harmony painted in oils and watercolors, showing an enviable capacity for synthesis in its resolution. In the lower paintings the artist exhibits his range of knowledge and experience in drawing and technique, in both watercolor painting (left column) and oil painting (right column).

124

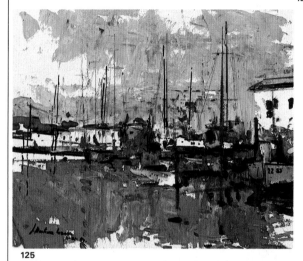

125

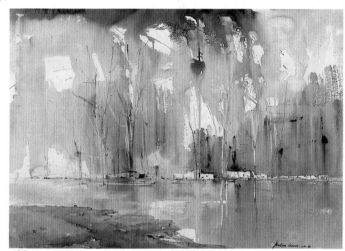

126

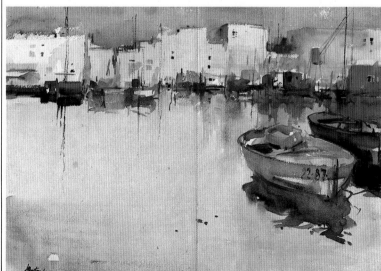

127

128

The materials used by Martínez Lozano

In the middle of the studio, Martínez Lozano has prepared his materials and tools for painting a watercolor: to the left, on top of a stool that sometimes serves as an extra table, is a special palette for watercolors that has color compartments arranged around the edges of a central space for color mixing. To the right, on top of another stool, the artist has placed a blue plastic bucket full of water. In the middle, leaning against a workshop easel at a slight incline, is a plywood board onto which the drawing paper is attached with four tacks.

Taking off from here, I start up an interesting conversation with the artist:

"Tell me, what paper do you use, what colors, how many brushes...? Is there any medium in the water?"

"The paper, Belgium Steinberg; the colors—Rembrandt in tubes. Two wide-ended number 20 or 24 sable-hair brushes and India ink for underlining some bits," he speaks very quickly, letting his words run into each other as though he were reciting the alphabet—something so basic that everyone should know it.

And the water—normal tap water. "This stuff about mediums improving adherence and serving as a moistening agent," he says smiling, "is one of those fairy tales told by those people who think that watercoloring boils down to tricks and household hints."

"Don't you ever mount your paper?" I ask to keep him going.

"Another fairy tale! You teachers should explain what *mounting* means for the beginners in the audience: It refers to wetting

the paper and taping it down with gummed tape before painting, in order to avoid warping and wrinkling from the wetness of the watercolors. I've always just fastened the paper to the board with four tacks and that's it. Of course, this method is perfectly all right as long as you paint on a thick, high-quality sheet of paper."

Martínez Lozano smokes cigars—one after another. He smokes while he talks, and while he paints the cigar sticks out of his mouth.

"What are you going to paint? A seascape?" I ask him.

129

130

Fig. 129. The setup: the palette on top of a stool, the water in a blue plastic bucket to the right, and an inclined plywood board with paper on it in the middle, leaning against a studio easel.

Fig. 130. Talking about Martínez Lozano's painting materials, I can't forget to mention the cigars that he constantly "uses" to paint.

Fig. 131. The special watercolor palette used by Martínez Lozano.

Fig. 132. Martínez Lozano paints with only two wide-ended sable brushes. The handles of these brushes are beveled. One is used for scratching and "opening" spaces, and the other is used for drawing with India ink as though it were a reed quill in the technique that we will soon see illustrated.

131

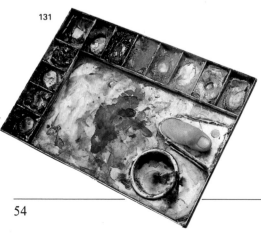

132

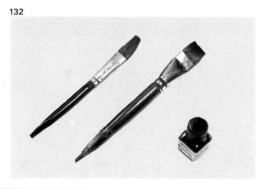

"Mount the paper? No, it's not necessary"

He looks at the flame of the lighter and says in a tone halfway between sarcasm and humor:

"Well, I've been labeled a seascape painter. And yes, it's true that I've painted a lot of boats taking off from the beach, a lot of ocean ports and fishermen's wharves, but I've also painted country landscapes, urban cityscapes...."

He leaves the sentence and gesture dangling, grabs a sable-hair brush, loads it with water, combs it over the deep madder, and lets it absorb. "For me, a painting is like a movie being projected inside my brain. I suddenly envision something like a neighborhood, the houses of suburbs—white houses, red sky, earth, a dark foreground... I see color...I see contrast."

He speaks with his eyes fixed on the white paper and his suspended brush pointing toward it. Then, chewing on his extinguished cigar, he looks at me and smiles as though begging my pardon, and returns to the paper and paint.

The miracle begins.

There's no way of defining in words what happened next at Martínez Lozano's studio: Without the benefit of any previous sketch, model, or draft, Martínez Lozano painted an extraordinary city scene in exactly fourteen minutes by merely imagining and improvising, by projecting his mental movie onto paper. The photographer and I were there to witness it. And I myself, Parramón, your mentor, thought that it would be impossible to explain what was hapenning in words.

"Just a minute, José," I say to Lozano, "we're going to capture the process in images by taking photographs as you work."

Then I gave the necessary instructions to Sigfrid, the photographer.

"Look, you'll have to alternate the shots between these three vantage points: from here, from the other side, and straight behind Martínez Lozano. Shall we go to it?"

On the following pages are photographs of the miracle as recorded step by step, second by second, brushstroke by brushstroke.

With a sheet of good thick paper and some tacks handy, it's not necessary to mount your paper. As you know the humidity of watercolor causes paper to expand, which in turn creates buckles, undulations, and wrinkles. The traditional form of avoiding this consists of wetting the paper with tap water or submerging it in a trough of water for a few minutes. Then one takes the paper, gently stretches it, and fastens it to a wooden board with four strips of gummed tape. Afterward, it is left to dry naturally in a horizontal position to make it taut enough to withstand the effects of dampness.

In spite of the effectiveness of this procedure, many professional watercolorists do not follow it. "To my mind it represents an unnecessary loss of time," says Martínez Lozano. "I work with a sheet of good thick drawing paper that looks like pasteboard, and I fasten it to a board with four tacks. I never have any problems."

133

134

135

Fig. 133. First submerge the paper in a pan of water or keep it under a tap of running water for approximately two minutes.

Fig. 134. The soaked sheet of water is then placed on a wooden board and gently stretched.

Fig. 135. Last of all, the four sides of the paper are quickly glued down with strips of gummed tape. All that's left is to let it dry for three or four hours while maintaining the board in a horizontal position.

136

Fig. 136. Like many other artists, Martínez Lozano doesn't mount his paper. He limits himself to fastening the paper to a board with tacks. Of course, in order to do this the paper must be thick and of very high quality.

A lesson in rapid watercolor painting

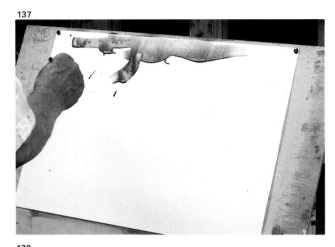

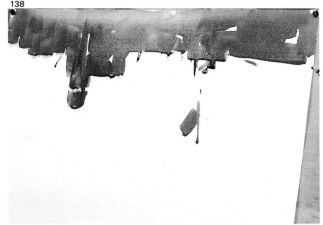

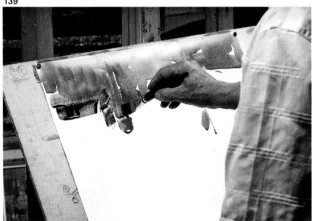

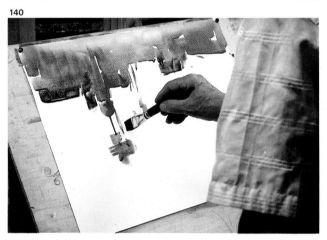

Martínez Lozano uses a sheet of un-wetted white paper with no previous drawing on it.

He starts to mix carmine, red, and ochre; he makes decisive strokes with the wide-ended, short-handled sable brush. You can tell that he's seeing the picture in his head, the entire picture.

Continuing to use the carmine, the red, and the ochre, he outlines profiles and shapes. Ten seconds, twenty, thirty.... He paints so quickly that he leaves behind little empty areas, little white spots that will remain visible in the finished work.

A mouthful of smoke and some Payne's gray is now added to the still wet background red. He continues to define forms with horizontal brushstrokes. Every once in a while there's a pause to wring the brush; he does it by pinching it dry over the water

Fig. 141. To get rid of excess water or paint, Martínez Lozano wrings out his brush by squeezing it with his fingers, as you can see in the photograph. "This way I can control the amount of water, color, or wetness that I need perfectly."

bucket with his fingers. The photographer and I watch in complete silence; you can only hear the click of the camera as it keeps taking pictures incessantly. Still using the wide-ended, short-handled sable brush he's now making vertical strokes, tracing lines that seem to outline forms, but what are they? What is the painting?

He puts down the brush and lights up the cigar. I inquire if they are houses, part of an urban landscape, and he nods, chewing on the cigar and disturbing the curls of cobalt blue smoke that he's emitting. He picks up some raw sienna and without thinking about it, as though it were predestined, he traces some large horizontal strokes at the foot of the houses. He paints and fills the area from left to right and as he moves right, adds some Payne's gray with a touch of ultramarine blue.

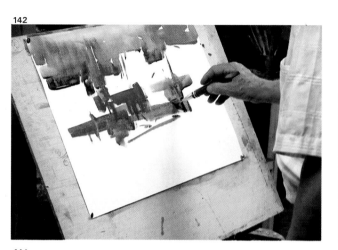

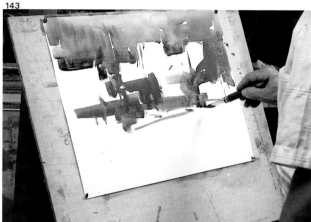

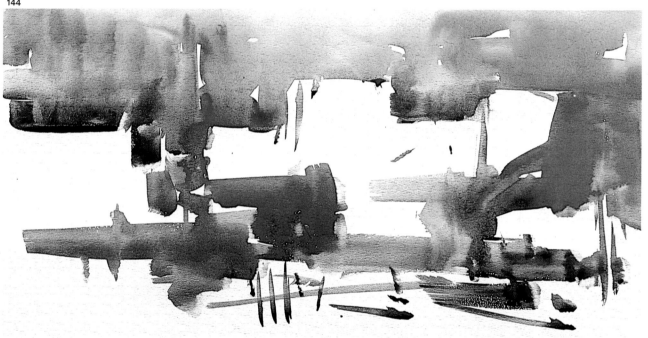

Finally, once he reaches the right side, he loads the brush with vermilion, wets this area, and at the same time spreads on the carmine. The outcome is a huge red blotch —wet-on-wet—that runs and creates irregular masses and blurs of color. This all happens quickly, very quickly. Five minutes have passed up to now. Sigfrid, the photographer, swears under his breath and says, "I should have brought an automatically timed camera!"

Figs. 137 to 140 and 142 to 144. Watch how Martínez Lozano's watercolor develops. It starts out with abstract forms, but ends up being the first phase of a figurative urban scene.

Painting from memory

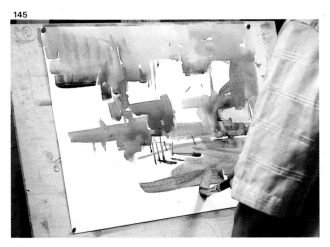

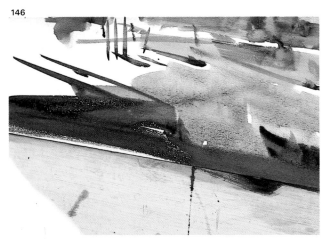

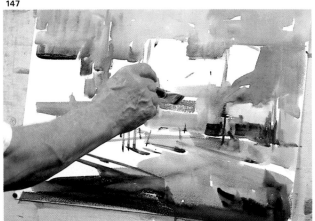

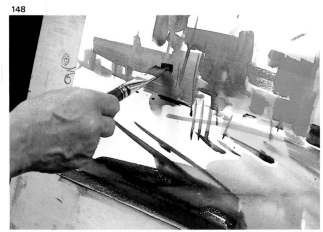

Two new colors amplify the spectrum of warm colors: a chrome orange-yellow and burnt sienna. Using these colors along with ochre and carmine and varying amounts of water, Martínez Lozano paints the ground —the asphalt of the street.

He looks at the painting, makes mental calculations, observes it intently, loads up the brush with dark yellow, and at the foot of the houses—because there's no longer any doubt that these are houses, that this is a street, an urban landscape—the artist paints a horizontal strip. He adds water and paints the background wall—which he will later convert into an awning—a light cream color. More water, more squinting of the

eyes, and within a few seconds of painting with wet and dry watercolor, he has completed the foreground with close contrasting colors, creating depth.

The movie's not over. It's just slowed down to slow motion now that the stressful part, painting the foreground, is over. There's an air of relaxation. He looks at me and smiles. "What do you think?" he asks.

"It's great, fantastic!" I respond.

He continues to stroke broadly, but slowly, with time to talk. "Watercoloring is the same as drawing; you have to create by drawing-painting. And you have to know about perspective." He makes a vertical trace, a pole, with red. "See these slanted

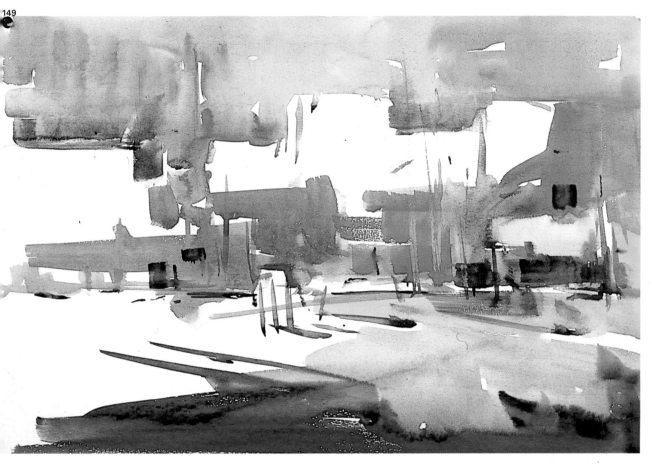

strokes?'' he says, as he points to the slant-ed lines of burnt sienna in the foreground. "These and the other ones further back in-dicate perspective, give the idea of distance and space.'' He paints the red area of the central house and explains, ''I was in need of these red strokes; this way the vertical plane of the wall separates itself better from the horizontal line of the ground.''

Martínez Lozano takes time to paint in the details: windows, doors. Using the tip of his brush handle, he makes vertical scratches on the red area and ''opens up'' a few strips of orange.

He looks at me, shows me the tip of his brush, and smiles: ''Yes, I already know

that there are special tortoise-shell brushes with beveled handles to make these kinds of strokes. But I prefer this wooden-handled sable brush. I use this one as a pen for draw-ing and outlining with India ink. Let me show you....''

Martínez Lozano picks up the inkwell, unscrews the top, wets the tip of this brush handle as though it were a quill and then....

But before going any further, look at the reproductions on these pages that follow the picture's development up to the present mo-ment.

Four more minutes have gone by to make it a total of nine minutes that he has worked on this painting.

Figs. 145 to 149. The pic-tures on these pages graphically trace Martínez Lozano's step-by-step painting of an urban scene. What these images don't capture is the diabolical quickness with which he paints each phase. Neither do they give us an accurate idea of the artist's spon-taneity and surety of tech-nique as he paints in a free-and-easy style of broad brushstrokes and color ap-plications that constantly risk ruining his final picture.

Using the brush handle as a pen

150

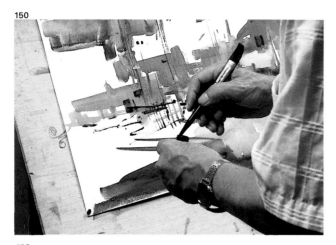

151

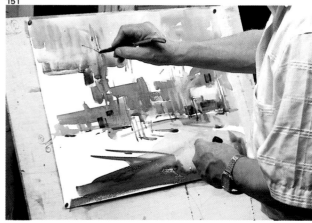

152

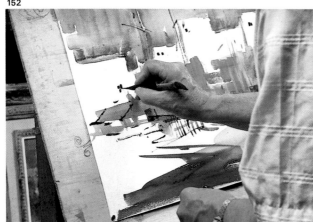

153

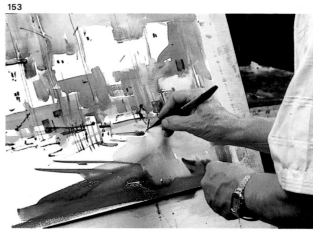

Martínez Lozano retrieves his cigar, lights it up, and takes a puff. He holds the inkwell of India ink in his left hand, dips in the tip of the brush handle, and traces a few lines, crossing them on top as though they were television antennae. He stops, sucks on the cigar, looks at me, and says behind a cloud of cobalt blue smoke, "Well the purists say that India ink shouldn't be used on a watercolor, but I ask myself what the difference is between a line of black India ink and a line of black watercolor?." He answers his own question, "Yes, of course, it's a difference of... voice... of mode of execution." He speaks and draws at the same time, interrupting himself when he has to make some kind of calculation, "Drawing with the tip of the handle is... is like drawing with a quill. The load of ink isn't smooth, so as you see," he stops and points, "some lines aren't completely black. They came out gray because there wasn't enough ink."

He stops talking, returns to the picture, and adds some small squares—the windows on the white walls of the houses. Once again he speeds up, brushing nonstop without hesitation. He looks at his picture as he wets the brush handle in the ink and then draws a kind of rhombus shape (that will eventually become an awning) to the left-hand side of the picture. Another awning on the right side, dots and dashes on the ground and on the wall... scratch, scratch! A little globule of India ink splatters down onto the painting! But he doesn't let it bother him. The artist keeps stroking, and with a few more lines and splotches he draws a figure, then another figure, then a third one. He puts the brush and the inkwell down on the

Figs. 150 to 155. Martínez Lozano doesn't agree with the watercolorists who think that drawing or underlining with black lines of India ink doesn't belong in true watercolors. "I honestly believe," says Martínez Lozano, as he chews and smokes on the cigar that he is never without, "that it's no different drawing or tracing lines with India ink than with black watercolor. The only advantage is that by using India ink and the curved handle of a beveled brush I come close to approximating a reed quill which offers a much richer selection of tones—everything from "India ink black" to a range of grays determined by the amount of ink on the quill.

154

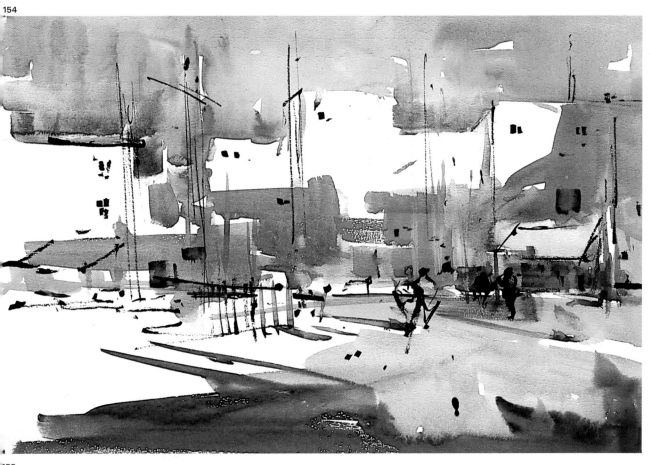

155

stool. His cigar has gone out again. He relights it. It's been a total of twelve minutes so far.

Now he's feeling communicative. He says, "We're almost finished," and continues, "Do you understand now? A model isn't crucial. You can paint with no model, no sketch, no nothing. All you need to do is think of a picture, see it in your mind and imagine its forms and colors."

He picks up another brush.

Martínez Lozano keeps talking as he holds the brush in his hand: "When I go outside and have a model in front of me I still see it my way. I interpret as I paint, emphasize the colors and the contrasts, imagine non existent blue or gray shadows, and think of the hues or shades only hinted at by the model, just as I have done painting here." He chews on the cigar and spews out smoke. "You have to invent with ideas you get from the model, you should only accept the model as a point of reference or departure, as an initial stimulus to seeing a real picture."

Imagination, interpretation, and creativity

Without thinking about it, as though he does it automatically, Martínez Lozano goes back to painting. He mixes a dark, dirty color out of Payne's gray, burnt sienna, and ultramarine blue and paints the shadows underneath the awnings on both sides of the picture. He darkens the wall of the right-hand house and spreads the same color under the houses in the middle ground and to the left of the figures. He cleans the brush with water and makes an ochre-yellow color which he applies to the wall of the right-hand side house. The humidity of this wash makes the wet India ink of the small sketched windows run. A visible blotch. But he remains immutable and—diluting the same ochre-yellow—he applies it to the left side of the street.

Afteward, as though it were the most natural thing in the world, he washes his hands in the water of the blue bucket, the same water that he used for his watercolor. He searches for a towel. With his hands up in the air like a surgeon about to enter an operating room, he says, "I think it's good to paint a picture from memory like this every once in a while—not using any models, just remembering things you've seen and using your imagination to add forms and effects. I think that these creative exercises are the best way to learn. Tell that to your readers."

He can't find the towel. He picks up the brush again, dips its handle in the ink, and signs his work.

It has taken Martínez Lozano a total of fourteen minutes to complete the painting.

156

Fig. 156. Whenever Martínez Lozano finishes a watercolor, he has the habit of washing his hands with water from the bucket that he used while painting. Why? The artist answers, "There's no real reason. I just started doing it one day and it ended up becoming part of my watercolor ritual."

Fig. 157. The artist's signature signed in India ink with the handle/brush/pen.

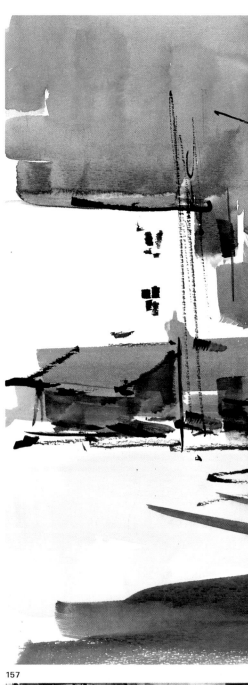

157

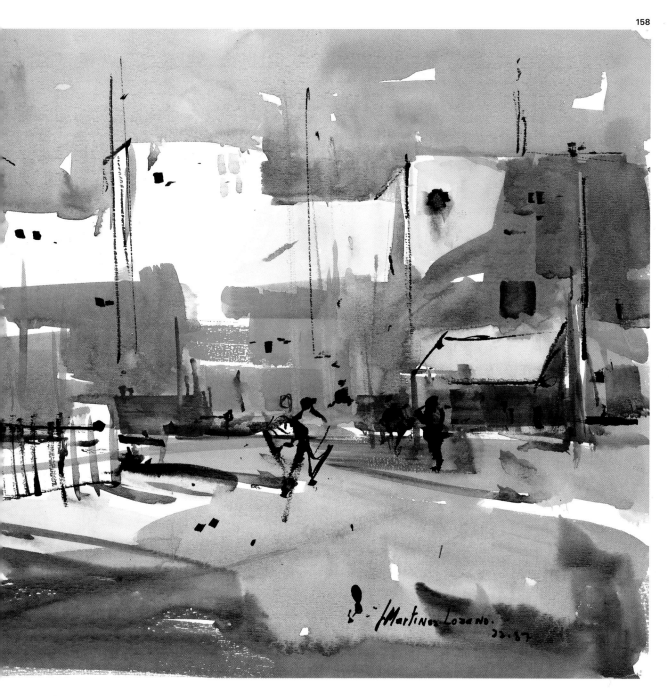

Fig. 158. This is the finished project: a watercolor that above all demonstrates Martínez Lozano's creative capacity to imagine and create a motif by painting from the mental "movie" that he sees in his head as he paints. On the other hand the painter's extensive knowledge of the fundamental rules of drawing and painting, such as structure, perspective, composition, effects of light and darkness, and contrasts, is also evident. And all of the above is highlighted by his extraordinary technical skill in applying colors, washes, dry grays, and muted colors, wet-on-wet.

Contents